IMAGES
of America

NEW ALMADEN

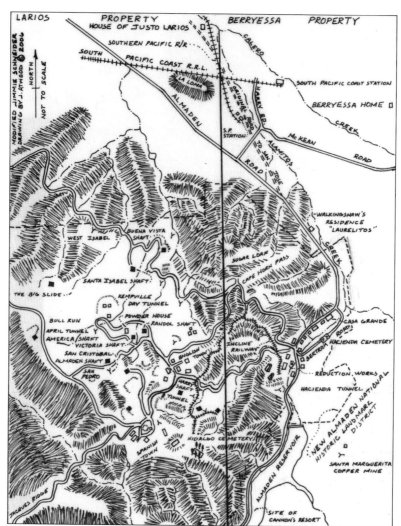

MAP OF NEW ALMADEN. This map shows the North-South line decided by the U.S. Supreme Court, which divided the mining area and removed the mining rights from Castillero's mining grant. It shows the community, the mine areas, and the borders of the New Almaden National Historic Landmark District, established by the U.S. Department of the Interior in 1963. Miners began settling New Almaden in 1845. Management and furnace workers lived in the canyon at the Hacienda. Miners searched for ore and settled in Spanishtown near the first mine entrance. As the Cornish entered the workforce, they settled nearby in Englishtown. After the Quicksilver Mining Company purchased the property from the Barron, Forbes Company in 1863, they added shafts and 100 miles of tunnels over the next 50 years. Railroads came to the edge of the mine property and teamsters drove stagecoaches to the settlements, bringing visitors, workers, payrolls, and supplies. (Map drawn by John Atwood based on Jimmie Schneider's 1952 map.)

ON THE COVER: At the gateway to New Almaden stands this stately structure called Casa Grande. Built of brick and wood frame, the exterior brick walls were plastered with a false stone texture. The five-acre setting was formally landscaped with flower gardens, shrubs, and a lagoon bordering Alamitos Creek. Taken in 1894, Robert Bulmore received a gold medal from the California Camera Club for this photograph, which he called "Reflection." (Courtesy Bulmore family.)

IMAGES
of America

NEW ALMADEN

Michael Boulland and Arthur Boudreault

ARCADIA
PUBLISHING

Published by Arcadia Publishing
Charleston SC, Chicago IL, Portsmouth NH, San Francisco CA

Printed in the United States of America

Library of Congress Catalog Card Number: 2006923347

For all general information contact Arcadia Publishing at:
Telephone 843-853-2070
Fax 843-853-0044
E-mail sales@arcadiapublishing.com
For customer service and orders:
Toll-Free 1-888-313-2665

Visit us on the Internet at www.arcadiapublishing.com

We dedicate this book to those miners who worked, lived, and died in New Almaden, to their descendants, and to friends who have preserved this community as a rural outpost in spite of the growth of Santa Clara Valley.

REGISTERED NATIONAL HISTORIC LANDMARK DISTRICT. The U.S. National Park Service honored New Almaden with this designation because of the important contributions to U.S. history made by this mining community. The discovery of mercury, just as the gold rush began, allowed the U.S. to recover gold and silver with no dependence on foreign sources. Such a dependence would have had serious consequences during the Civil War.

CONTENTS

ACKNOWLEDGMENTS

Several early photographers, including Carleton E. Watkins, Milton Loryea, John Macauley, Dr. Smith E. Winn, and Robert Bulmore, took hundreds of photographs at New Almaden. Many early writers, including J. Ross Browne, Samuel B. Christy, Mary Hallock Foote, W. V. Wells, and later writers Edgar H. Bailey, Laurence Bulmore, Judge Alex Innes, Kenneth Johnson, Milton Lanyon, and Jimmie Schneider provided the background that allowed us to place photographs and captions into context. The Historic American Building Survey provided photographs on their Web site. Consultants Leslie Dill and Charlene Duval provided much historical data. Thanks go to the members of the Bulmore, Randol, and other families who gave us permission to use copyrighted photographs from their collections. The New Almaden Quicksilver County Park Association and Mining Museum provided other photographs.

We are eternally grateful to the many families who have preserved their own materials and made them available to the New Almaden Quicksilver Mining Museum, and especially to Constance Perham who opened the mining museum in the 1940s and collected materials for over 50 years. We are indebted to the Santa Clara County Parks and Recreation Department, especially Robin Schaut and her staff, Mary Berger, Chris Bullock, John Slenter, and Terri Williams, for their assistance and encouragement. The contributions of members of the New Almaden Quicksilver County Park Association, namely John Atwood, Michael Cox, John Drew, Thomas Graham, Virginia Hammerness, Robert Meyer, Kitty Monahan, and other volunteers were invaluable. We especially thank our wives, Dorene Boulland, and Sarah Boudreault, for their patience with us. We also thank Arcadia Publishing and our editor, Hannah Clayborn, for their technical assistance in producing a current and dynamic history of our community. The authors take full responsibility for any errors that may have occurred. A complete index, found at www.newalmaden.org, was too large to print in this book.

Find more fascinating history on this subject at the New Almaden Quicksilver Mining Museum at 21350 Almaden Road, San Jose, California, 95120. Please call (408) 323-1107 for museum hours.

INTRODUCTION

New Almaden is the location of the first mining community in California. In 1963, the U.S. Department of Interior recognized the historic importance of New Almaden and listed the area on the National Register of Historic Places. The community is located 12 miles south of San Jose and 15 miles from the old port of Alviso.

The Ohlone Indians lived in this area and were the first to discover the vermillion red rock. They used it for trading, religious ceremonies, and as body paint. When Spanish settlers arrived at New Almaden, José Reyes Berryessa claimed the Rancho San Vicente and Justo Larios claimed the Rancho de Los Capitancillos for farming and ranching. In 1845, during the Mexican era, Andrés Castillero discovered that the Ohlone's red rock was cinnabar, the ore that contains mercury. Since the Rothschild family of France held a monopoly on mercury production, the Mexican government offered a large reward for the discovery of a mercury mine in their territory—it was crucial to the recovery of gold and silver. When the United States won the Mexican War late in 1846, the U.S. government purchased Texas and California from Mexico. Andrés Castillero then sold his interest to the Barron, Forbes Company from Tepic, Mexico. The company was the first partnership here to commercially develop mercury from cinnabar, and they renamed it the New Almaden Mine. Visitors rode the stagecoach from Alviso to New Almaden until the Southern Pacific Railroad extended its lines to New Almaden from San Francisco. Henry Halleck managed the mine for Barron, Forbes Company until the Civil War, when he became general-in-chief of the Union army. Over the next 50 years, New Almaden was the site of the richest mine in California, surpassing the monetary value of any gold mine in the state. The mine captured the attention of important politicians, including Abraham Lincoln, president of the United States. After Barron, Forbes Company uncovered legal problems concerning the validity of the Castillero mining grant, the company sold its interests to the Quicksilver Mining Company. In 1863, Samuel Butterworth turned down an appointment to the Mississippi State Supreme Court in order to become president of the Quicksilver Mining Company. After he retired in 1870, his nephew James Butterworth Randol brought the mine and the town to their golden years. In addition to encouraging modern mining methods, he developed an entire community that included health care, entertainment, police, fire protection, and schools. Describing the vibrant community the company built is the primary focus of this book. Following the discovery of mercury, the first miners arrived from Mexico, Chile, and other South American mining communities. Cornish miners from Cornwall, England, followed when Randol became manager. Three settlements in New Almaden were formed—the Hacienda, where management and the furnace workers lived, and Englishtown and Spanishtown, where the miners lived. The population grew to include other nationalities, including some Chinese. At its peak, over 3,000 people lived in New Almaden.

In 1854, Henry Halleck commissioned a large mansion, the Casa Grande. It became the site for visits by many important men and women of San Francisco and as the residence for mine managers. After the Quicksilver Mining Company went bankrupt in 1912, George Sexton purchased the assets. He and his heirs owned and operated the mining area for the next 50 years.

They reopened the Senador Mine and built new furnaces and housing at the north end of the mining property.

After Sexton's death in 1926, his heirs subdivided the New Almaden Hacienda community. Wealthy San Francisco residents purchased the existing homes as summer resort cabins and built houses on empty lots. Developers bulldozed a road through the Hacienda Cemetery and created Bertram Road as a loop on the east side of Alamitos Creek back to Almaden Road. The Black brothers converted Casa Grande into a resort area called Club Almaden. The Mount Madonna Company of the Civilian Conservation Corps workers lived in Englishtown from 1933 to 1939 in order to remove the miners' cabins throughout Englishtown and Spanishtown. Often corps workers were pulled away to fight grass and forest fires throughout Santa Clara Valley.

As the Second World War approached, Sexton's heirs initiated new efforts at high-volume mercury production. They installed a new 35-ton rotary furnace in Spanishtown and began stripping the top of Mine Hill for its ore. After the war, mining continued as individuals leased the mines from the family. Around 1960, Jimmie Schneider, author of *Quicksilver, the Complete History of Santa Clara County's New Almaden Mine*, and several others purchased the property to develop it for 1,800 homesites. The development was never built. Eight years later, the New Idria Mining and Chemical Company bought the mines from them and added a new 100-ton rotary furnace. Within a few months, the price of mercury dropped and the company quickly abandoned the mining operation. The Santa Clara County Board of Supervisors purchased the property for a county park in 1976. In 1998, the Santa Clara County Parks and Recreation Department purchased the Casa Grande to house the New Almaden Quicksilver Mining Museum.

One

EARLY YEARS

After the Costanoan or Ohlone discovered a vermillion-colored rock on the Capitancillos ridge above what became New Almaden, the Tamien, Awaswas, Muwekma, Mutsun, and other tribes traded this rock all along the Pacific Coast and up to Oregon. They used it in religious ceremonies and painted their bodies with a powdered form.

In 1845, Andrés Castillero discovered that the ore was cinnabar and claimed mineral rights to 3,000 varas (or 1.58 miles) centered at the mouth of the Indian Cave. This claim included land previously granted for grazing and farming. When Castillero's workers mined the cave, they discovered that it had been tunneled for several feet beyond a cave-in. Here they found ancient human bones, confirming the Ohlone stories about their mine. Castillero returned to Mexico to secure his claim, but could not return to California after the Mexican War because he was an officer in the Mexican army. Eustace Barron and Alexander Forbes purchased his shares and also purchased the Berryessa land at the Hacienda. They hired a superintendent, Robert Walkinshaw, who designed brick furnaces, to replace the early try-pots. The company also hired a lawyer, Henry Halleck, who was fluent in Spanish and an expert in Mexican land claims. First given a retainer of $30,000 to lock in the land claims, Halleck was then hired to manage the mines. He left in 1861 and eventually became the general-in-chief of the Union army.

The Quicksilver Mining Company purchased the adjacent Larios-Fossat claim and began operation at the Enriquita Mine, convinced that the Castillero mining claim was defective. In 1863, while the U.S. Supreme Court was deciding the land and mining claims, President Lincoln's former law partner, Leonard Swett, who secretly owned shares in the Quicksilver Mining Company, obtained a writ from the president that allowed him to seize the New Almaden Mine property. The U.S. marshal, C. W. Rand, and a company of soldiers backed down when Halleck countermanded Lincoln's order. Then the Quicksilver Mining Company purchased Barron and Forbes's interests for $1.75 million and took over operations in late 1863.

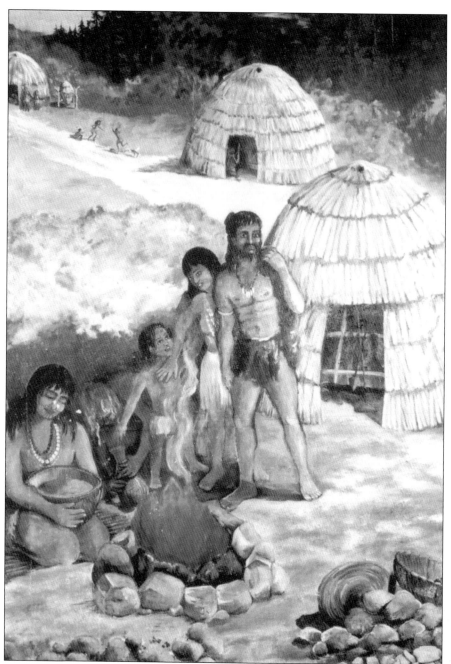

OHLONE VILLAGE. The Ohlone people lived in large villages within a few miles of New Almaden as long as 8,000 years ago, though no archaeological sites have been identified in the town itself. (Some surviving artifacts contain red paint, identified as cinnabar from New Almaden.) In these villages, 50 to 500 Ohlone lived and built their homes of tule reeds attached to a skeleton of flexible willow saplings. These huts, about 12 feet in diameter, held 10 to 15 members of the village. The Ohlone lived in their villages most of the time, but often traveled to temporary settlements to fish and harvest acorns and to places where they manufactured spear points and arrowheads. (Photograph by John Slenter.)

Don Secundino Robles. In 1824, Ohlone Indians showed Don Robles the cave where they retrieved their red-pigmented rock. Secundino and his father, Téodoro, took Capt. Andrés Castillero to the mouth of this cave 21 years later. Castillero quickly registered his own claim with the local *alcalde* (mayor) on November 12, 1845, as "a vein of silver, with a ley of gold, on the land of José Reyes Berryessa." (Courtesy California Pioneers Society.)

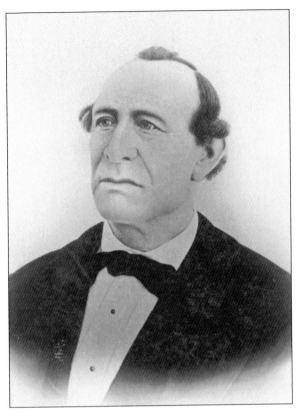

Don Antoñio Maria Sunol. Secundino Robles described a "red rock" cave in the hills to Don Antoñio Sunol and Luis Chabolla. Sunol thought it was silver, but when they were unable to prove that, Sunol and Chabolla abandoned their quest. In 1845, Sunol served as a witness for Andrés Castillero when he established his claim for the quicksilver mine in front of Alcalde Antoñio Maria Pico. (Courtesy James F. Delgado.)

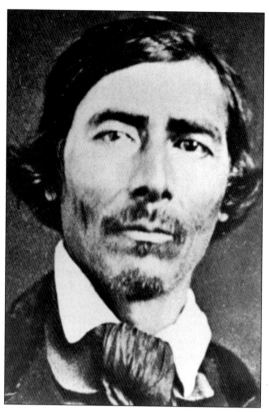

JUSTO LARIOS. Mexican governor Juan B. Alvarado granted two land grants in 1842, one to José Reyes Berryessa and the other to Justillarios, the 4,470-acre Rancho de los Capitancillos. Justillarios's name is also recorded as Justo Larios, the son of a Mexican soldier, José Larios. Three years after he was granted the rancho, Larios sold it to Grove C. Cook for $350 in silver and $25 in goods. (Courtesy Clyde Arbuckle collection.)

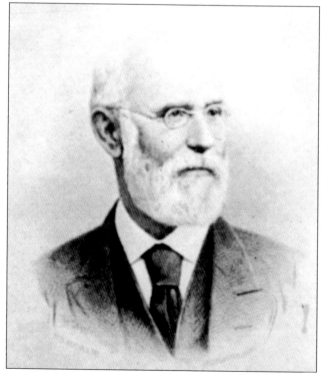

ALEXANDER FORBES. After Alexander Forbes, not related to James Alexander Forbes, and Eustace Barron of Tepic, Mexico, purchased the quicksilver mine in 1850, they renamed it the New Almaden Mine. The Barron, Forbes Company employed John Young as superintendent and hired hundreds of miners and furnace workers. In 1863, they sold the mine to the Quicksilver Mining Company after the U.S. Supreme Court decided that it did not own the mining rights.

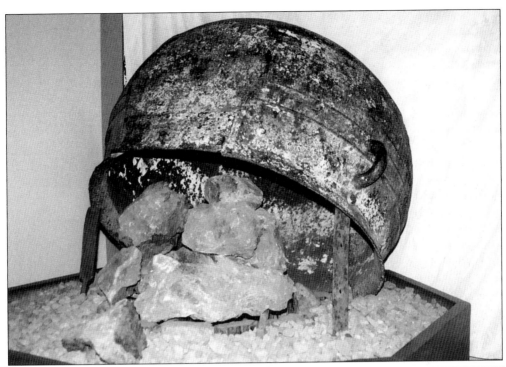

WHALING TRY-POTS. Early in 1846, Robert Walkinshaw purchased six whaling try-pots from Monterey fishermen. Workers placed ore on a grate over a water-filled pot. Another try-pot was inverted over the ore, sealed, and heaped with firewood. The fire was lit, the rocks heated, and mercury vaporized. The mercury vapor was forced into the bottom try-pot where water cooled and condensed the steam into mercury. (Photograph by John Slenter.)

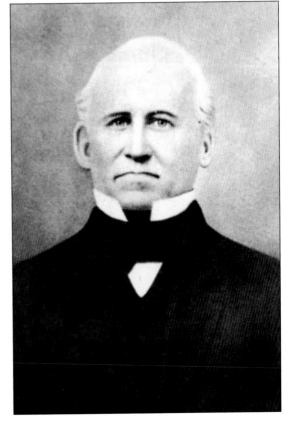

EARLY MINE MANAGER. James Alexander Forbes managed the mines for Castillero and his partners when Castillero returned to Mexico. When the Barron, Forbes Company purchased the claim from Castillero in 1846, Robert Walkinshaw arrived to manage the mine. Forbes continued to work with the Barron, Forbes Company to secure the mining claim for Castillero's partners. In 1850, Forbes left and established the Forbes Flour Mill in Los Gatos, California.

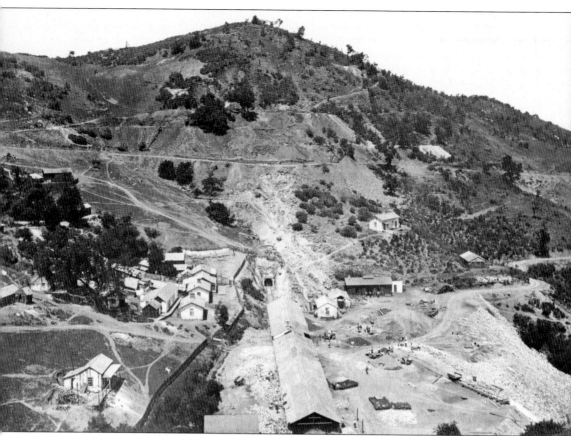

MAIN TUNNEL. In 1850, the New Almaden Mining Company placed the main tunnel into service. The tunnel was on the southeast slope of Mine Hill at the head of Deep Gulch. It ran 807 feet into the mountain to a point 300 feet below the Mine Hill summit and just below the original Indian Cave. Workers at the large sorting shed (*planilla*), seen at lower center, sorted the cinnabar by grade. Most miners were paid by the *carga*, or wheelbarrow load. Miners were not paid for ore dust, called *tierra*, which was taken to the Hacienda and mixed with adobe and made into bricks for later roasting. During these early years, ore that assayed at less than 200 pounds per ton was discarded into nearby dumps. Workers' homes were built near the tunnel in what was called Spanishtown. This photograph was taken *c.* 1863. (Photograph by Carleton E. Watkins.)

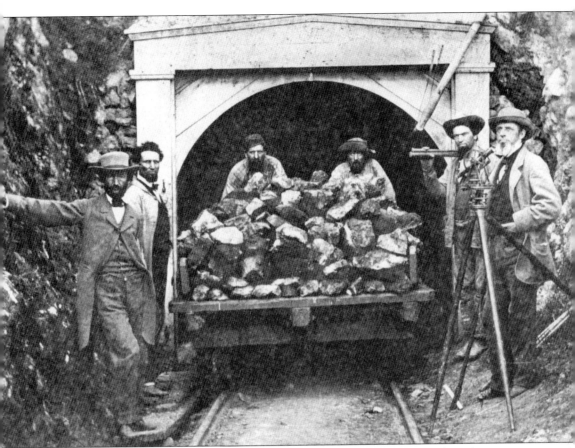

Entrance to the Main Tunnel. Miners, pictured here around 1863, emerge from the entrance to the main tunnel with a full load of cinnabar. The tunnel was added to speed the removal of ore from the Indian Cave. It was 10 feet wide, 7 feet high, and included a double-track, narrow-gauge railroad for the large ore cars. At the far right is Sherman Day, surveyor and later mine superintendent. Day resigned, effective October 31, 1864, with the following statement: "with the intended reduction of my salary to $300 per month after 1st Nov. next, I certainly shall not remain at that salary, and therefore herewith tender my resignation." Sherman Day was originally from Pennsylvania where in 1838 he published the *Historical Collections of the State of Pennsylvania*. Day was also the designer of the rail system on Mine Hill and installed the incline railroad that substantially reduced the time and cost of transporting ore to the Hacienda. (Photograph by Carleton E. Watkins.)

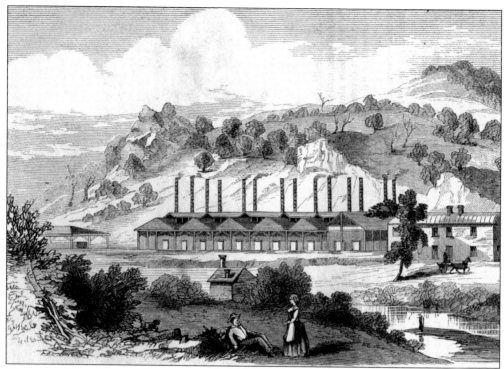

HACIENDA MINE WORKS. Beginning in 1847, workers built furnaces, a boardinghouse, the mine office, a machine shop, and a blacksmith shop at the Hacienda, near Alamitos Creek at the foot of Deep Gulch. Discovery of the New Almaden cinnabar lode 28 months before the discovery of gold at Sutter's Mill, allowed the United States to remain independent of Rothschild's mercury monopoly. (Courtesy W. V. Wells, *Harper's New Monthly Magazine*, 1863.)

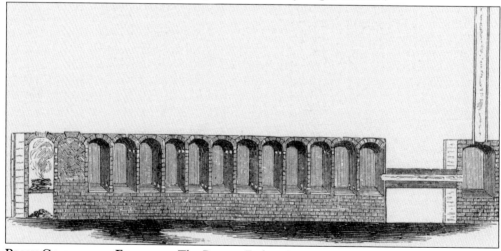

BRICK CONDENSING FURNACES. The Barron, Forbes Company installed 16 furnaces to replace the whalers' try-pots. The heat from the fire traveled through a charge of ore, and the mercury-bearing fumes traveled through condensing chambers. Mercury collected on the cool bricks and dropped to the bottom. Fumes vented through the chimney. The furnaces were 40 feet long, 10 feet high, and 8 feet wide. (Courtesy H. V. Wells, *Harper's New Monthly Magazine*, Volume XXVII, June 1863.)

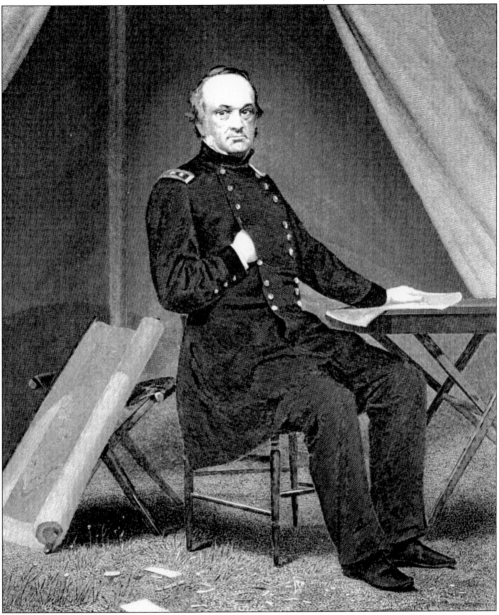

HENRY WAGER HALLECK (1815–1872), 1862. Halleck graduated third from West Point Military Academy in the class of 1839 and distinguished himself in the Mexican War. He resigned his commission in 1853, joining the law firm of Halleck, Peachy, and Billings in San Francisco. The Barron, Forbes Company provided a $30,000 retainer to the firm so that Halleck, an expert in Mexican land grants and well-studied in Spanish, could advise them on the reliability of their claims to the mines. The Barron, Forbes Company then hired him as mine manager from 1853 to 1861. Halleck commissioned the Casa Grande, which was built by Francis Meyers. In 1861, he was recalled into military service and entered the Civil War as a general. He took over the Fremont campaign in Missouri and became the commanding general of the Union armies in 1862. In 1863, he was instrumental in preventing the seizure of the mines by the U.S. government. Following the Civil War, he retired to Lexington, Kentucky. (Engravure by Alonso Chappell.)

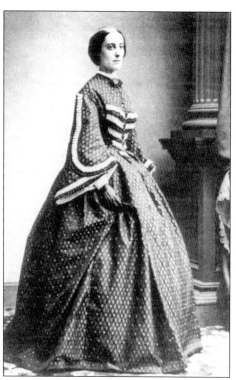

ELIZABETH HAMILTON HALLECK (1830–1884). A granddaughter of Alexander Hamilton, Elizabeth, pictured here around 1855, married Henry Wager Halleck in 1855. Their only child, Henry Jr., was born in 1856. After her husband's death in 1872, she married Brevet Maj. Gen. George Washington Cullum (1809–1892) on September 23, 1875. Cullum had served as chief of staff to General Halleck during the Civil War. (Courtesy Harper Wright and the Randol family.)

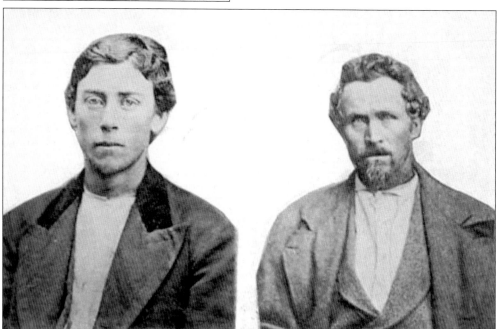

ROBBERIES IN NEW ALMADEN. Large payrolls at New Almaden attracted many robbers. During the Civil War, bandits holed up at a farm on Almaden Road and prepared to rob a stage carrying the New Almaden Mining Company's payroll, but the sheriff's posse caught them, and the robbers were imprisoned. In Spanishtown, Mexicans often sheltered lawbreakers. One robber, Tiburcio Vasquez, was finally captured here and hanged in San Jose. (Courtesy John Slenter.)

Two

Travel to
New Almaden

The native Ohlone climbed Deep Gulch Trail to the Capitancillos Ridge to reach their sacred cave. When they took Castillero to the cave, the party rode horses, taking only an hour to reach the mine area from the Hacienda.

When the mines became well known throughout the United States, visitors regularly arrived from the East, sometimes by way of newly formed wagon trails, but more often by ship, sailing into San Francisco Bay and by ferry to Alviso. In 1857, W. V. Wells reported that the cost of a ticket was $40, but he traveled by horseback along the East Bay from Oakland to the Hacienda.

As the population of New Almaden grew, the Almaden Stage Line provided transportation for mail, passengers, payroll, and workers. With stables set up on Almaden Road, Frank Bohlman provided teamsters who transported lumber, firewood, and supplies to the community. At one point, he had 35 mule and horse teams working in New Almaden.

Early in 1886, Jim Fair, owner of the South Pacific Coast Railroad, provided a narrow-gauge railroad to New Almaden to transport redwood timber from Los Gatos and Santa Cruz and constructed a terminal at Harry Road, just east of Alamitos Creek. After Leland Stanford extended the Southern Pacific Railroad to the Richmond (later known as Greystone) Quarry, he continued his standard-gauge line to McKean Road, west of Alamitos Creek and just a few hundred yards from Jim Fair's depot. Stanford purchased the Southern Pacific Coast Railroad in late 1886, then removed the terminal and added a narrow-gauge track within his own standard-gauge tracks. With the advent of the automobile, rail lines were abandoned. Bus lines now provided transportation for the public. In the 1970s, the Valley Transportation Authority purchased the private bus lines, which continued service until 2004.

New Almaden's residents continue to ride horses in the community, both for ranching and for traveling through the area. Pedestrians, equestrians, and bicyclists now use the old mining roads to wind through the Almaden Quicksilver County Park, enjoying the beauty of the rolling hills of New Almaden.

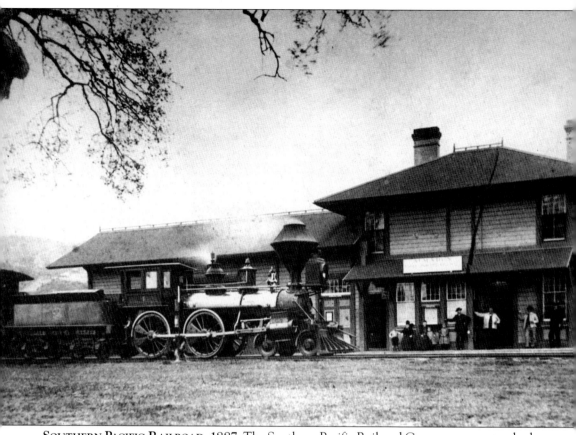

SOUTHERN PACIFIC RAILROAD, 1887. The Southern Pacific Railroad Company ran a standard-gauge branch line from San Jose to New Almaden. The station was at McKean and Cahen Roads, two miles from the New Almaden settlement. Service began on November 16, 1886, and played an important part in serving passengers and freight during the boom years of quicksilver mining. Passengers completed the journey to New Almaden by stagecoach. Teamsters transported freight to the mines. Danforth, Cooke, and Company of Patterson, New Jersey, built engine No. 4 in 1863 for the San Francisco and San Jose Railroad. This engine was named *Comanche*, but in 1891, it was renumbered "IIII." The engine continued service until January 1893 and was dismantled in San Francisco. This New Almaden depot was moved to Aromas, California, in 1924. (Photograph by Robert Bulmore.)

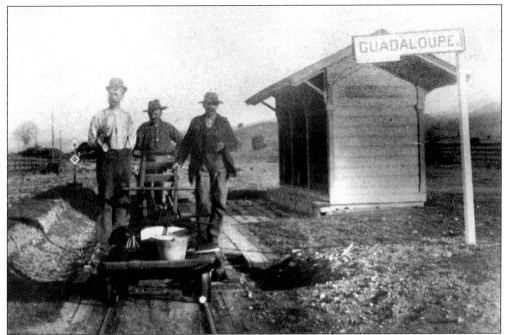

GUADALOUPE STATION, C. 1890. Near the junction of Redmond Road and Coleman Avenue, about seven miles north of New Almaden, this railroad station served the nearby Guadalupe Mines. It was typical of the stations along the Campbell–New Almaden route of the South Pacific Coast Railroad. After the Southern Pacific Railroad purchased the line, the narrow gauge continued to be used until 1900.

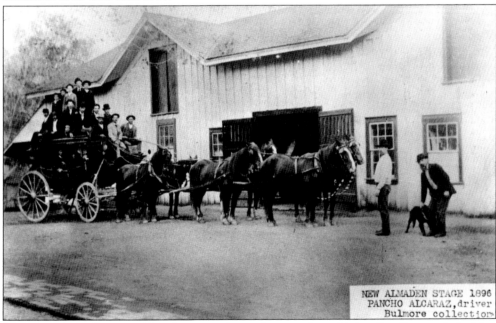

NEW ALMADEN STAGE 1896
PANCHO ALCARAZ, driver
Bulmore collection

NEW ALMADEN STAGE, 1896. Stages made regular runs from Alviso, San Jose, and the New Almaden train depot to Frank Bohlman's stable on Almaden Road. Pancho Alcaraz, seated left at the front of the stagecoach, is the driver. (Photograph by Robert Bulmore.)

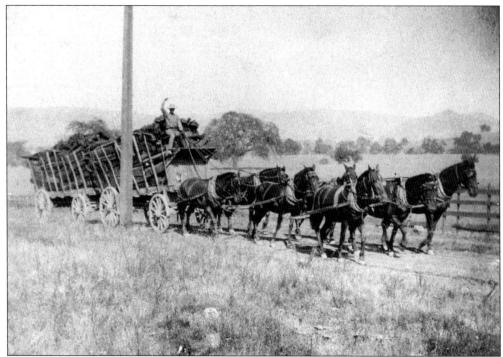

SEVEN-HORSE TEAM, c. 1895. Thomas Stiles hauled wood obtained from the Uvas area for the furnaces at the Hacienda Mine Works. He used a hitch where three horses led, followed by two sets of two horses. In 1893, Stiles worked as a gardener. His brother William was a furnace foreman, who began working at the age of 10. (Photograph by Robert Bulmore.)

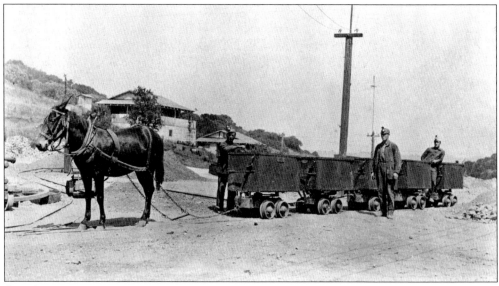

ORE CARS AT THE SENADOR MINE, 1917. A single horse pulled ore cars full of cinnabar, about one ton per car, from the Senador tunnel to the newly built Herreschoff furnace. These cars were returning to the tunnel entrance. The spur at the left led to the dump where spent ore and loose rock were unloaded. First explored in 1864, the Senador Mine was worked primarily between 1917 and 1926.

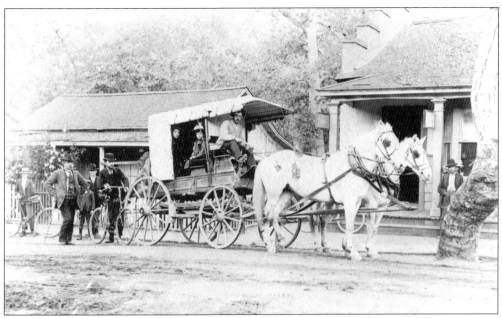

RICHARD BERTRAM BARRETT (1885–1959). The stage arrived at the Hacienda store and discharged passengers and freight. After the 12-mile run from San Jose, the horses would be exchanged for fresh ones at the Bohlman stables nearby for the return trip. Pictured here in 1900 at the extreme left, a young "Bert" Barrett, who lost his left arm in a hunting accident, held his bicycle behind the stage. (Photograph by Robert Bulmore.)

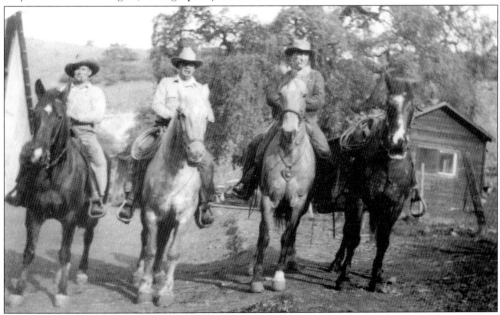

RANCH HORSEMEN. Ranchers grazed cattle on land originally claimed by José Berryessa. Paul Hourét purchased the ranch in 1928 from the Sexton estate. The original Hacienda School once stood on the site of the Hourét ranch, north of Bertram Road. Pictured, from left to right, are Charles Mousque, Richard Bertram Barrett, and Paul Hourét Sr. Photographer Ray Barrett left his horse to take this photograph, c. 1935. (Courtesy Paul and Mary Hourét.)

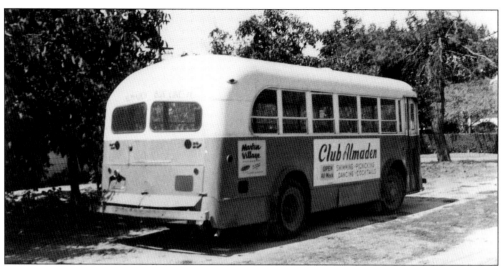

ALMADEN STAGE LINES, c. 1950. Bert Smith owned the Almaden Stage Lines before 1937 and sold his franchise in 1940, after closing the New Almaden line. In 1946, Paul Steiling resurrected the Almaden Stage Lines. Norman Holmes, owner since 1956, suspended operations of the New Almaden route in 1959 when City Lines extended its No. 3 line in 1958. Club Almaden was located at Casa Grande. (Courtesy Norman Holmes.)

FARES
ALMADEN TO SAN JOSE

Almaden - View Point Lane	$0.15
Almaden - Coleman Road	.20
Almaden - Robertsville	.25
Almaden - Hacienda Gardens	.25
Almaden - Valley View Pack (Hillsdale & Almaden)	.30
Almaden - Monterey Manor	.30
Almaden - Tully Road	.35
Almaden - San Jose	.39

SAN JOSE TO ALMADEN

San Jose - Tully Road	.15
San Jose - Monterey Manor	.20
San Jose - Valley View Pack (Hillsdale & Almaden)	.20
San Jose - Hacienda Gardens	.25
San Jose - Robertsville	.25
San Jose - Coleman Road	.30
San Jose - View Point Lane	.35
San Jose - Almaden	.39

ALMADEN

STAGE

LINES

SCHEDULE

TIMETABLE NO. 5

EFFECTIVE APRIL 26th
1954

BUS SCHEDULE. In 1954, the Almaden Stage Lines scheduled six daily round trips from New Almaden to San Jose. Eight stops along the way included View Point Lane, Coleman Road, Robertsville, Hacienda Gardens, Valley View Pack (Hillsdale and Almaden), Monterey Manor, and Tully Road. It ended at the Greyhound terminal in downtown San Jose. Passenger charges varied from 15¢ to 39¢.

Three

CASA GRANDE

Identified as one of the most historic buildings in Santa Clara County, Casa Grande is listed on the National Register of Historic Places. Casa Grande welcomed 19th-century visitors who traveled along Almaden Road into New Almaden. As visitors entered the five-acre estate either on a sweeping driveway or through an elegant gate in the white picket fence, they gazed on a stately, three-story building with a veranda covered in shrubs, vines, and roses. As they entered the hallway, visitors found a parlor and a library to the left and a drawing room to the right. Beyond the drawing room was the dining room. Staircases led them to the upper floor where there were eight bedrooms or below to the servants' quarters. At the rear of the home was the beautiful garden with fountains, pools, and a huge pagoda used for family activities, picnics, plays, and concerts.

Mine manager Henry Halleck commissioned Casa Grande; it was completed in 1855. After Halleck became a general during the Civil War, every succeeding Quicksilver Mining Company manager lived there, including Samuel Butterworth, James B. Randol, Capt. James Harry, Robert R. Bulmore, and Thomas Derby. After the Quicksilver Mining Company's bankruptcy, George Sexton maintained the property and resided there when he visited from New York.

In 1927, the Black brothers purchased Casa Grande from Sexton's heirs. They lived on the third floor and opened the lower two floors for commercial activities. They replaced the beautiful gardens with several swimming pools and established a summer resort called Club Almaden. Through various owners, Casa Grande continued to be a popular place to shop and hold parties. In 1981, Terry Esplanade began renovating the building and removed the stucco-like material on the exterior to expose the brick structure.

In 1998, the Santa Clara County Parks and Recreation Department purchased Casa Grande and moved the New Almaden Quicksilver Mining Museum into the main floor. The department is now restoring this beautiful example of 1850s architecture to its former elegance.

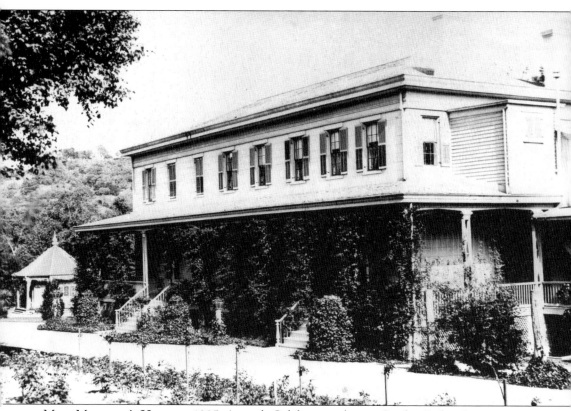

MINE MANAGER'S HOME, C. 1885. An early California architect, Gordon Parker Cummings was probably the designer of Casa Grande. Frank Meyer began construction in 1854 and completed it in 1855. Henry Halleck and other managers entertained guests from all over the world as the mercury mine received major worldwide publicity. Before 1861, the grounds were planted as a vineyard. In 1882, Robert Ulrich designed the gardens and lagoon for James B. Randol. He formally landscaped the five-acre setting with lawn, flower gardens, and shrubs bordering Alamitos Creek. Water from the creek was diverted into the lagoon. An Austrian landscape gardener, Gustav Magnison, managed the grounds with the assistance of John McLaren. The addition of the upstairs toilet room, upper right, over the veranda was believed to be the first indoor toilet in California. After 1925, Casa Grande was converted into a commercial enterprise that included living quarters on the top floor, a bar, several shops, a post office, a dance hall, and a theater on the main level. (Photograph by Robert Bulmore.)

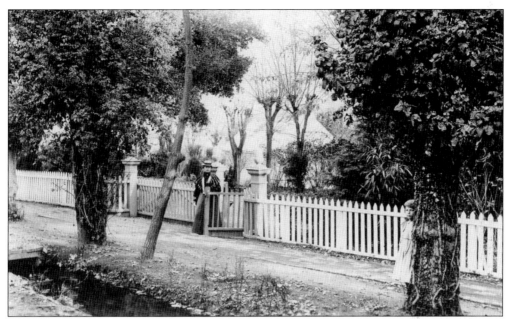

FRONT GATE AT CASA GRANDE, C. 1890. Lottie Bulmore, daughter of Robert Bulmore, entered the Casa Grande grounds through the south gate. A young girl, Olive Barrett, watched the photographer from behind the tree. Water in the *acequia* (irrigation ditch) flowed north toward Alamitos Creek. Almaden Road residents used this water for cleaning and for their gardens. (Photograph by Robert Bulmore.)

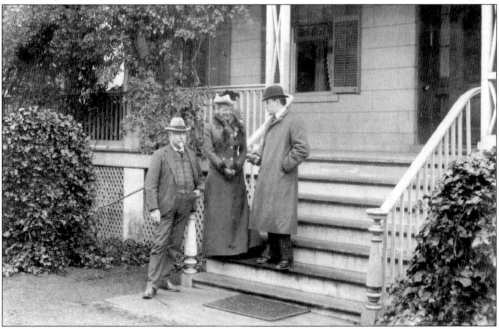

HONEYMOON AT CASA GRANDE. Mary Randol Carroll and her husband, Charles, visited the former home of her father, James B. Randol, on December 8, 1900, while on their honeymoon. They posed with Thomas Derby, left, the Quicksilver Mining Company mine manager, who welcomed them to his home. (Courtesy Harper Wright and the Randol family.)

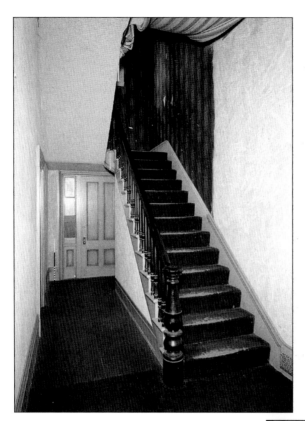

CASA GRANDE ENTRY HALL, 1936. A parlor and a library were on the left and the drawing room was on the right. To reach the eight bedrooms on the third floor, the family climbed 21 stairs to the top. Visitors could pass through the hall and the rear door to view the elegant gardens and Alamitos Creek. (Courtesy Historic American Building Survey.)

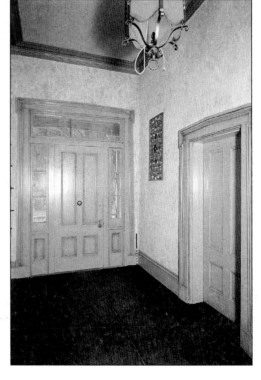

CASA GRANDE ENTRANCE, 1936. The entrance to Casa Grande was located between the formal parlor and the family living room. The Georgian-style door frames were common to the 1850s. Ten-inch thick interior brick walls were covered in plaster about one inch thick, painted several times, and wallpapered. The earliest color painted was a robin's egg blue. (Courtesy Historic American Building Survey.)

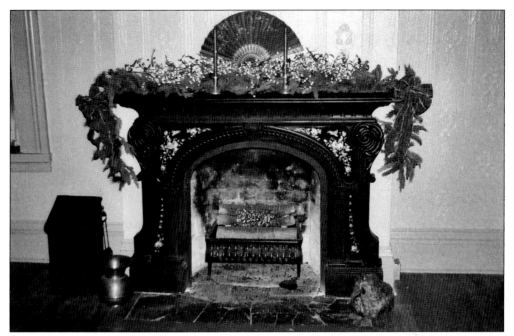

DINING ROOM FIREPLACE. Imported from Spain by Henry Halleck, the fireplace on the south wall warmed the Casa Grande dining room. It was decorated in mother-of-pearl and colored tinfoil. A later resident sold the fireplace around 1924, and Constance Perham subsequently purchased the fireplace for her museum. In 1998, the Santa Clara County Parks and Recreation Department purchased the fireplace and returned it to Casa Grande.

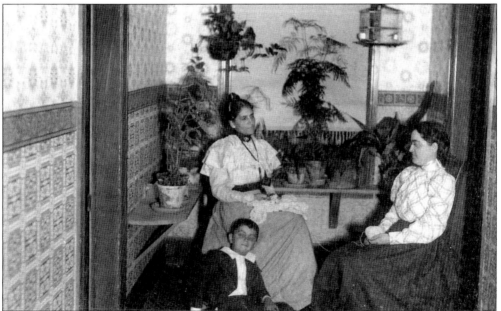

CASA GRANDE INTERIOR, C. 1898. The upper floor of Casa Grande was the living quarters for the mine manager's family. The hall extended the length of Casa Grande and included a small sitting room. Mrs. Robert (Refugio Banales) Bulmore crocheted while her son Laurence slept at her feet. Her maid, R. Hilda, holds a ball of yarn. (Photograph by Robert Bulmore.)

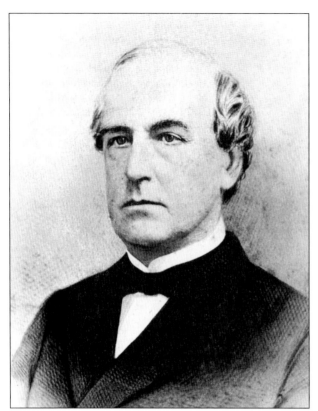

SAMUEL FOWLER BUTTERWORTH (1811–1875), 1867. Declining an appointment to the Mississippi Supreme Court, Butterworth became president of the Quicksilver Mining Company, which purchased the assets of the New Almaden Mining Company in 1863. He established order on the mine property and improved ore production. In 1865, the company produced 47,149 flasks of quicksilver, which grossed the company $2,166,304. Butterworth's estate was valued at $7 million. (Courtesy Bulmore family.)

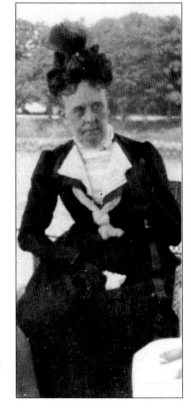

CHRISTIANA TERHUNE RANDOL (1845–1919), C. 1910. Before their arrival in New Almaden, Christiana Terhune married James Butterworth Randol in Passaic, New Jersey, on June 1, 1865. She hosted many events at Casa Grande from 1872 through 1892. When the couple invested in real estate in San Jose, many properties, including their San Jose home on Spring Street, were titled in her name. (Courtesy Randol family.)

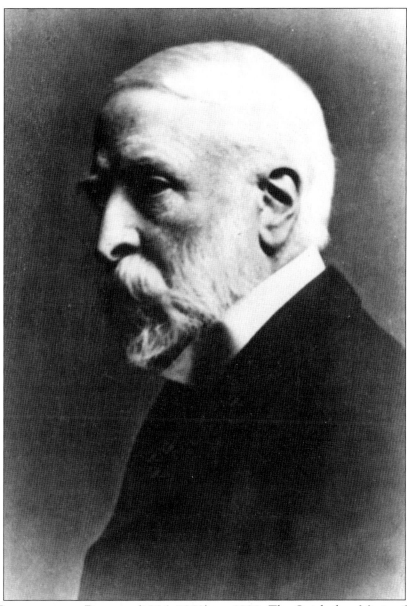

JAMES BUTTERWORTH RANDOL (1836–1903), C. 1890. The Quicksilver Mining Company hired James B. Randol as secretary of the corporation in New York. When his uncle Samuel Butterworth retired as mine manager in 1870, Randol became the general manager at an annual salary of $12,000. Faced with declining revenues, Randol initiated several changes to improve mine operations, including conversion of the furnaces from batch type to a continuous type called Scott furnaces. In 1871, he constructed the Randol Shaft, which produced 300 tons of ore per day. He added several more shafts in the 1880s. Interested in the welfare of his employees, he provided company health benefits by establishing a Miners' Fund into which employees paid $1 per month for medical care. For the next 40 years, company doctors were on the company payroll, beginning with Randol's brother Albert. Used for entertainment, the company built three Helping Hand Clubs where employees could read from the 450-volume library. When Randol retired, he returned to New York where he passed away.

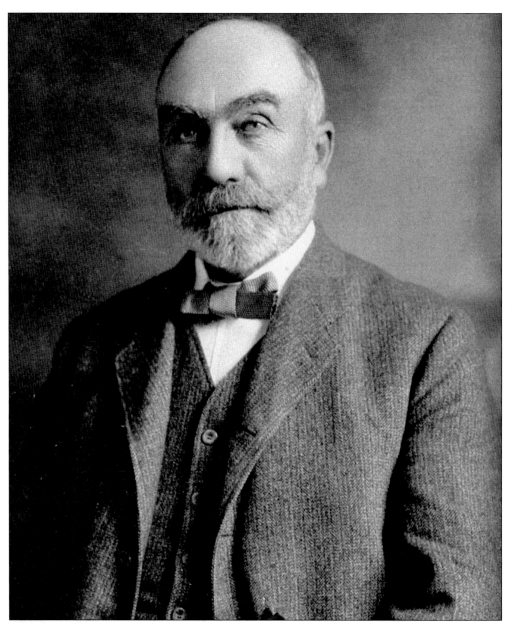

JOHN MCLAREN (1846–1943). McLaren, pictured here in 1900, emigrated from Scotland in 1869 and arrived in California having the distinction of being the only graduate from Edinburgh University, Scotland, who had a degree in gardening. Hired by James B. Randol to work under an Austrian, Gustav Magnison, he landscaped the beautiful gardens on the Casa Grande estate, moved the pagoda, and installed a lagoon fed from Alamitos Creek. He became the superintendent of Golden Gate Park in 1887 and served for over 55 years until his death at 96. He was described as "the little Scot with the green thumb. God must have been very close to the gnarled little Scot whose life became intertwined with San Francisco." In addition to his work at Golden Gate Park, McLaren laid out the original plans for James Phelan's Villa Montalvo in Saratoga after the 1906 San Francisco earthquake and fire. He was also responsible for the beautiful floral displays at the 1915 Panama-Pacific International Exposition in San Francisco.

CASA GRANDE GARDEN, 1886. James B. Randol received $6,000 per year to maintain the house and grounds. He lived in Casa Grande with his wife, Christiana, and their six children, who enjoyed playing in the gardens. To care for his home and family, he employed a seamstress, laundress, and three Chinese workers—a cook, a waiter, and a servant. (Photograph by Robert Bulmore in *Views of New Almaden*.)

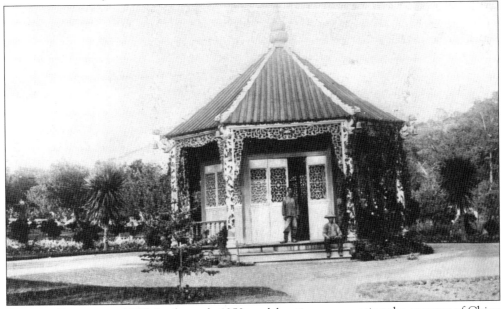

CHINESE PAGODA, C. 1885. In the early 1850s, a delegation representing the emperor of China arrived at New Almaden to negotiate a contract for mercury. Grateful for the hospitality to his emissaries, the emperor presented this Chinese pagoda as a gift. A group of Chinese workers installed the pagoda across Alamitos Creek. (Photograph by Robert Bulmore.)

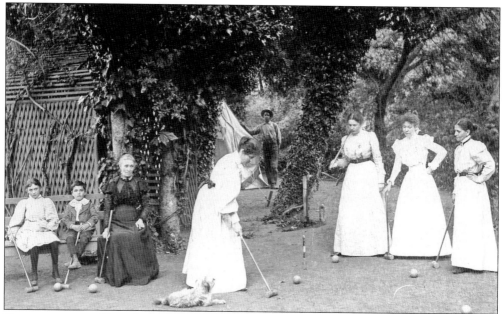

CROQUET AT THE CASA GRANDE, C. 1899. Croquet was a popular game in the 1890s. Pictured, from left to right, are Marion Fouratt; Laurence Bulmore, who later wrote *Cinnabar Hills*, a book about New Almaden; Mrs. Charles Macmillan Sr. from India; Mrs. Enos Fouratt; Miss Lottie Bulmore; Miss Macmillan, also from India; and Refugio Banales Bulmore. An unidentified young man is observing from the background. (Photograph by Robert Bulmore.)

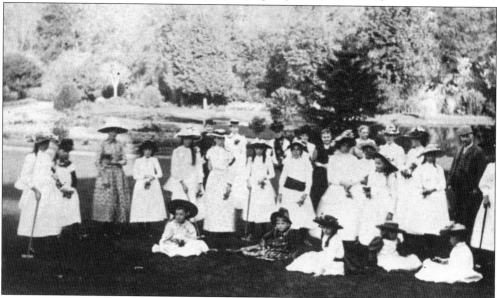

GARDEN PARTY, 1890. Guests enjoying themselves, from left to right, are (first row, sitting) Hattie Carson, Carrie Lawler, Laura Bohlman, Minnie Cantera, and unidentified; (second row) Mabel Buzza, Maud Tregoning, Maggie Lawler, Ada Anderson, Lottie Buzza, Rosie Higgins, unidentified, Eva McComas, Phillie Barrett, Josie Cantura, Allie Barrett, and Lily Buzza; (third row) Mrs. Frederick Von Leicht, Lottie Bulmore, Mrs. Frank Bohlman, Mamie Randol, Christiana Randol, Betty Randol, Mabel Barrett, Anne Buzza, and Thomas Derby.

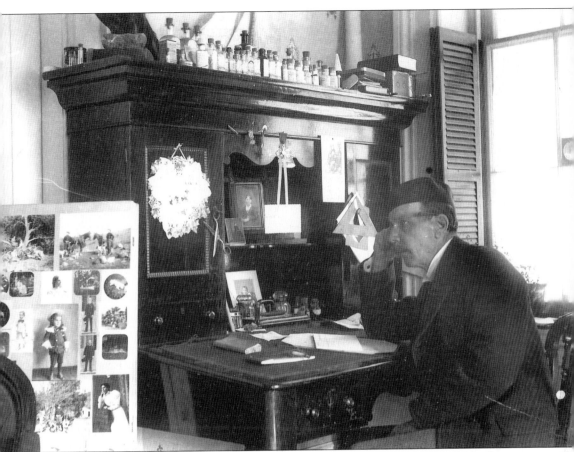

ROBERT RICHARD BULMORE (1840–1922). Bulmore, pictured here around 1895, was born in London and worked as an accountant for several years in India and Hong Kong. In September 1878, he joined the Quicksilver Mining Company as the accountant and foreman. He and his family lived in Bulmore House until his appointment as general agent in 1895. The family then lived in Casa Grande until December 1899. He spoke four languages—Hindustani, Chinese, Spanish, and English—and was married four times, to Frances Ann Davies, Josefina Banales, Emma Fowler, and Josefina's sister Refugio. Bulmore's father-in-law, Juan Banales, is buried in the Hacienda Cemetery. As a skilled photographer, Bulmore preserved New Almaden history for 30 years. His underground photographs at the mine may well be some of the earliest flash photographs ever made. Here Bulmore is seated in his library at the Casa Grande office examining some of his photographs. (Courtesy Bulmore family.)

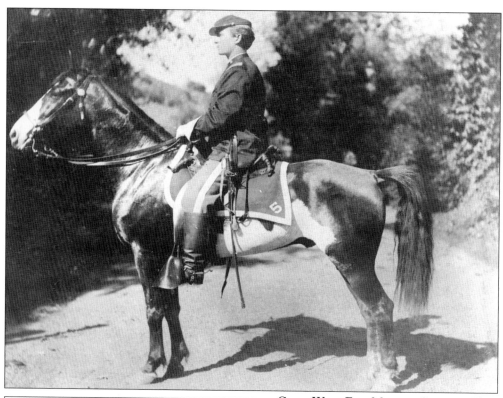

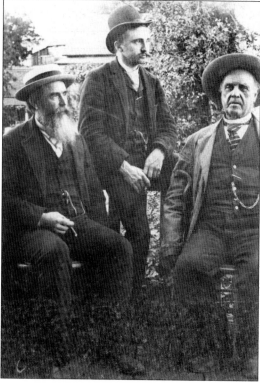

CIVIL WAR–ERA MILITIA OFFICER. The New Almaden Cavalry was organized on February 20, 1864, and disbanded on June 2, 1868. A total of 151 men served. Commanding officers, all captains, were George Tolman, M.D., who also served as New Almaden's doctor, Lewis F. Parker, and Arthur T. Foster. Shortly after the militia formed, Samuel Butterworth issued an order to prevent the militia from meeting or storing weapons on company property.

PROMINENT RESIDENTS, 1890. Pictured, from left to right, are Judge George Lighthall, principal at the Hacienda School and justice of the peace; James W. Wilkerson, mining company surveyor; and Francis Meyers, the carpenter who built Casa Grande and other homes on Almaden Road. Meyers's last project was the Santa Isabel Shafthouse in 1877. At 75, Meyers testified at the 1887 trial investigating rumors of election rigging. (Photograph by Robert Bulmore.)

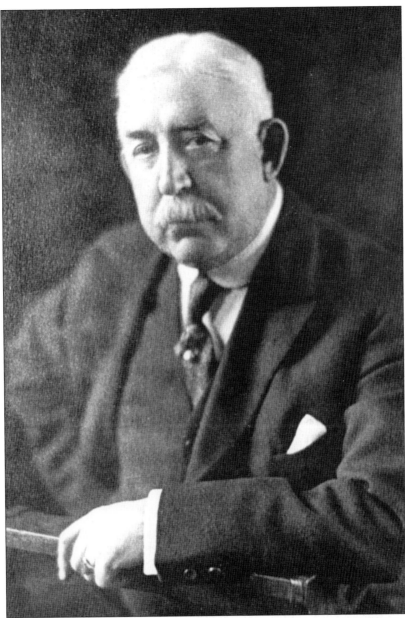

GEORGE SEXTON, C. 1920. Sexton, who lived in New York, leased and then purchased the bankrupt Quicksilver Mining Company in 1915, naming his new company the New Almaden Quicksilver Mining Corporation. When he traveled to New Almaden, he stayed at Casa Grande. He was paid expenses of $500 for each cross-country trip. He hired Fred Hauck as the company's accountant in 1915 and John Drew as superintendent in 1920. A few months later, H. R. Plate developed a report about the mine. When Sexton believed this engineer instead of Drew, Drew resigned. Two years later, Sexton asked John Drew to return. After the mining company operated at a loss in 1924, Sexton developed a grandiose plan to convert Casa Grande into a golf course and establish an exclusive residential settlement nearby. One of his children, William Lord Sexton, had loaned his father $750,000. When his father died in San Mateo early in 1926, the children inherited the estate and sold the Hacienda and the old furnace yard. (Courtesy Schneider collection.)

Louis and Adelaide Artnous, c. 1890. Louis Artnous (1865–1940) was born in a Mexican camp to French and Mexican parents. Artnous married Adelaide Carrillo (1867–1947), who was born of Mexican parents at the New Idria Mercury Mine, south of Hollister. Louis worked and lived in New Almaden his entire life. He worked on Mine Hill until an accident crushed his left leg. He then worked at the furnace yard. In 1910, he and his wife worked as gardener and housekeeper at Casa Grande, living in the servants' quarters until 1924. They retired to their own home on the west side of Almaden Road. Louis, a lover of the theater, once stated proudly, "We even had our own Opera House. The great actor Frank Bacon once gave several benefit performances in Englishtown. So enthusiastic was his reception that three performances raised enough funds to build the theater." (Courtesy Artnous family.)

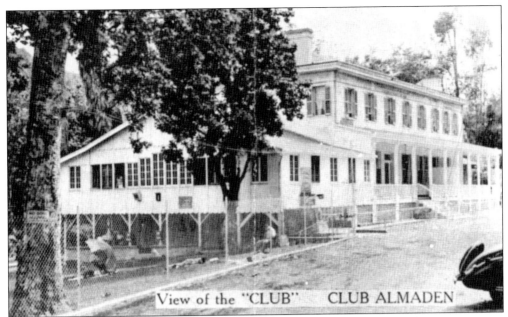

View of the "CLUB" CLUB ALMADEN

CLUB ALMADEN, 1935. David Black, the first private owner of Casa Grande, formed a resort in 1927 for summer guests. He lived on the upper floor. Club Almaden advertised "Dine—Dip—and Dance." Three large swimming pools allowed young and old to lie in the Alamitos Creek waters and sunbathe and picnic on the grounds. Swimmers paid 35¢ and non-swimmers paid 10¢ during the week. Prices were higher on Sundays.

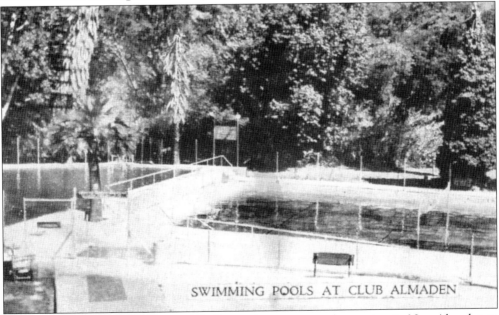

SWIMMING POOLS AT CLUB ALMADEN

SWIMMING AT CLUB ALMADEN, 1935. Swimming was a popular pastime in New Almaden as both residents and visitors visited the cool areas along Alamitos Creek at Casa Grande. Beside swimming and sunbathing, visitors used shaded areas with barbecue pits to picnic and chose among horseshoe pits, badminton, volleyball, tetherball, shuffleboard, ping-pong, and dancing to jukebox accompaniment to pass the time. Club Almaden operated until the late 1970s.

OPRY HOUSE, 1998. In 1925, a dance hall, where old-time melodramas were held, was built on the north side of Casa Grande. In 1951, Norman Pope created an indoor "Opry House" and an outdoor "Wagon Stagers" theater. In 1984, Sue Kroninger, Club Almaden manager said, "The curtain has been rising on the ever-changing Barbary Coast players for more than 20 years." Melodramas continued here until 2000.

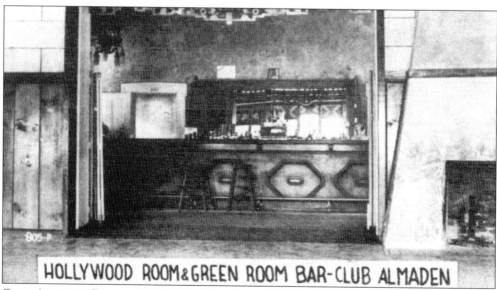

CLUB ALMADEN BAR, C. 1940. Club Almaden entertained its guests at an elaborate bar called the Old California Bar, situated in what had formerly been the parlor and library of Casa Grande. The bar, pictured above, was previously on the bottom floor. (Courtesy John Drew.)

Four

ALMADEN ROAD

Native American tribes traveled the original road to New Almaden from San Jose following the trail along Calero and Alamitos Creeks to Deep Gulch. It proceeded along today's Redmond Road and Camden Avenue and branched at Queenswood Way to the south, joining Almaden Road at McKean Road and ending at the Hacienda. Climbing Deep Gulch Trail, Native Americans approached their *mohetka* (cinnabar) mine entrance. They left pictographs in the caves throughout the area.

Castillero began his furnace operations on the flat 11-acre site at the Hacienda. His workers built wooden shacks and then adobe and brick houses near the entrance to the Hacienda Mine Works. The mining companies built many more homes along Almaden Road. Company houses received number designations on the 1880 map drawn by superintendent Frederick Von Leicht and in the company's rent roll books. Residents paid rents of $5 to $7 per month.

Relatives of James B. Randol, including his brother Albert, who was the first resident doctor, lived in house No. 1. When Dr. Randol died, Randol's brother-in-law Robert Burnett Smith, who was the company accountant, moved in. John Young, mine manager after Henry Halleck left, lived in house No. 2. H. J. Hüttner, who designed the continuous furnaces, and Robert Scott, who built them, lived side by side in houses No. 3 and No. 4. Fred Hauck, the company accountant from 1915 to 1928, lived briefly in house No. 5. The teamster, Frank Bohlmann, lived in house No. 6. Before his appointment as mine manager, Robert Bulmore lived in house No. 11.

The Carsons lived in house No. 12, which became famous as the original location of the New Almaden Mining Museum and the home of Constance Kambish-Perham. House No. 18 was the physician's office as well as the office of the justice of the peace. Frank Bohlmann owned the stable, and Tom Derby ran the general store. Several workers lived in the adobe apartment building known as the Tollgate House, including a Mutsun Indian named Antonio Soto, who lived there in 1880.

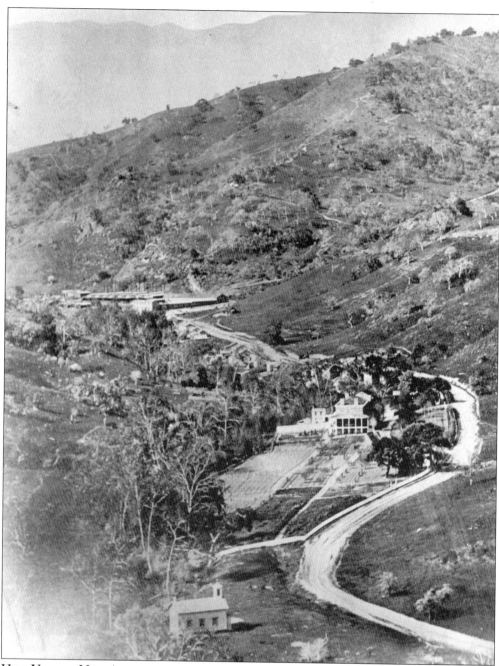

HILL VIEW OF NEW ALMADEN, C. 1857. Shady, tree-lined Almaden Road welcomed visitors to New Almaden after the hot, dusty ride from San Jose. The white stucco Casa Grande (center) was the inviting building that greeted newcomers with lush orchards and gardens. Well-kept white cottages dotted the banks of Alamitos Creek and lined the road. A brick sidewalk and an *acequia* running the length of the settlement were highlighted by red geraniums growing in profusion. The 16 furnaces at the Reduction Works (left center) were stoked with wood cleared from the surrounding hills. The road ended at the Hacienda Mine Works, where cinnabar was processed into mercury. (Courtesy Mike Boulland.)

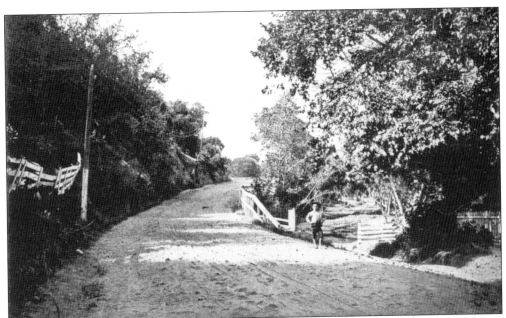

ALMADEN ROAD, C. 1886. Beginning in the 1840s, Almaden Road followed the banks of Alamitos Creek. During the mine's production era, the road was used to transport the miners' payrolls, as well as lumber for the furnaces and valuable shipments of mercury ore to sailing ships at Port Alviso. A constant stream of visitors traveled from San Francisco to New Almaden, keeping the residents current to the latest fashions.

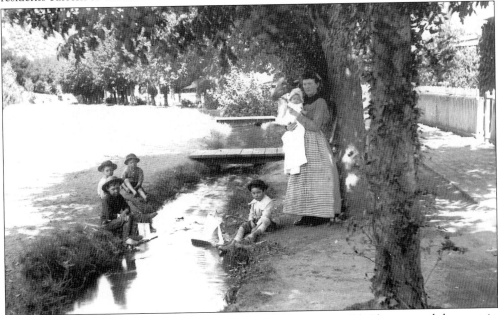

SAILBOATS IN THE ACEQUIA, C. 1885. In front of the homes, small bridges crossed the *acequia*, where children played in the water with homemade sailboats. The villagers used the *acequia* as a non-potable water supply. Chickens, horses, and geese walking by the roadside lent noticeable character and charm to the old mining town. (Photograph by Dr. Smith E. Winn; courtesy Bulmore family.)

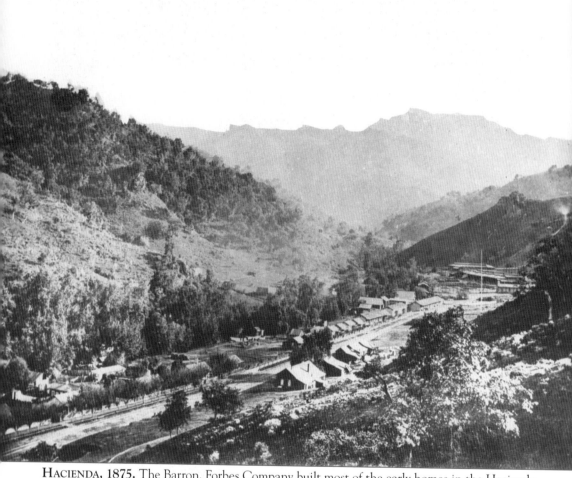

HACIENDA, 1875. The Barron, Forbes Company built most of the early homes in the Hacienda along the banks of Alamitos Creek. As the community of workers and managers increased, the Quicksilver Mining Company added more homes, charging rents from $5 to $7 per month. Several adobe, brick, and wood buildings were constructed near the entrance to the Hacienda Mine Works, but in 1874, fire destroyed some of the buildings. Of the surviving adobe buildings, only three are standing today. The Carson House, the Kirk House, and La Casita De Adobe (lower left) retain their past charm, while the mine office was demolished in 1963, and the company store burned in 1973. A sulfur odor from the intermittent furnaces was a part of daily life until chimneys on the hill behind the mine works were constructed to alleviate the Hacienda of the wood and sulfur fumes. A large stable, between houses in the center of the photograph, was constructed on the vacant lot by the creek to handle the Wells Fargo stage.

HOURÉT ESTATE, 1941. In 1928, the Hourét family purchased the land at the entrance to New Almaden to operate a dairy farm. In 1939, the Houréts built their two-story, Spanish-style family home at the intersection of Bertram Road and New Almaden Road. Today wild turkeys, deer, pigs, and domestic cattle can be seen in the pasture next to the home. (Courtesy Hourèt family.)

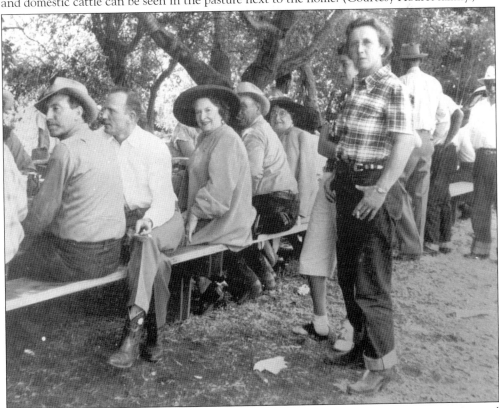

BARBECUE AT THE HOURÉT RANCH, 1948. The Almaden Range Riders, a horsemen's social group, held its annual picnic in New Almaden on the Hourét ranch. Some of the gang, from left to right, are Ted Lamantia, Chester Bennett, Mrs. McAbee, Joseph Aguiar, Mrs. McAbbe's sister, and A. P. Bernard, with his back to the camera. (Courtesy Paul and Mary Hourét.)

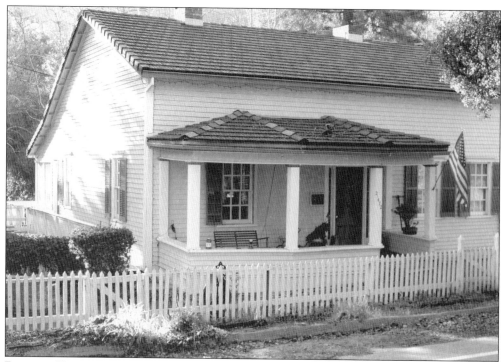

RANDOL HOME. Site of the mining office in 1856, house No. 1 was purchased in 1863 by the Quicksilver Mining Company to house the head mining engineer. In 1876, Dr. Albert Richards Randol, James Randol's brother, lived in the house. Replacing him in 1878 was Dr. Frederick V. Hopkins.

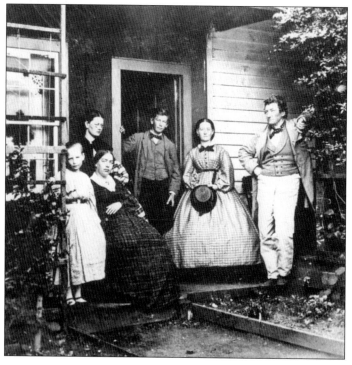

JOHN YOUNG FAMILY, c. 1863. Mine manager John Young, far right, posed with his wife, Marcello Walkinshaw (seated) and their children in front of house No. 2. When President Lincoln's writ to give up the mine arrived via U.S. marshal C. W. Rand, Young refused to relinquish ownership of the mine property. This ended secessionist fears that the Lincoln administration was attempting to seize all the mining areas west of the Mississippi. (Photograph by Carleton Watkins.)

ROBERT BURNETT SMITH, C. 1885. The Quicksilver Mining Company and Miners' Fund accountant, Robert Smith, and his family lived in house No. 1 in the early 1880s. (Courtesy Harper Wright and the Randol family.)

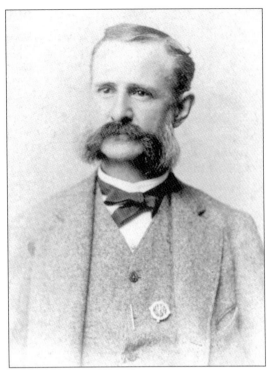

RANDOL FAMILY PORTRAIT, C. 1885. The Randol children and their cousin, a daughter of Robert Burnett Smith, dressed in fashionable Victorian clothing, posed in relaxed positions to prevent movement and blurring of the photograph. Pictured here, from left to right, are (first row) Samuel (born 1878), William (born 1869), Mary Clarita (born 1874), Frederick (born 1866), and Elizabeth (born 1872); (second row) Smith's daughter and Garrit (born 1867). (Courtesy Harper Wright and the Randol family.)

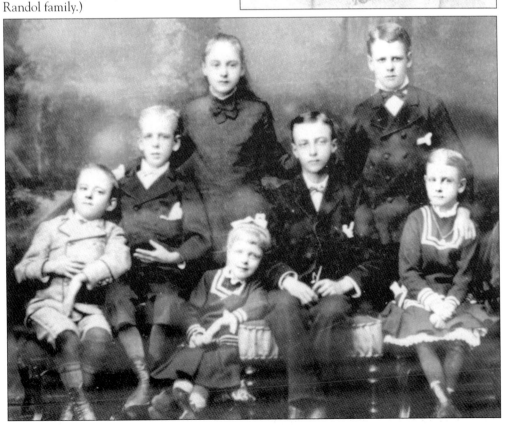

HÜTTNER RESIDENCE. The plaque in front of house No. 3 recognizes H. J. Hüttner, a mechanical engineer who designed and patented the efficient and continuous running Scott-Hüttner Furnace that replaced the original brick furnaces. House No. 3 was rented to N. Salazar in 1865; Sinforaso Vargas, a laborer, in 1868; and John Philbon, a carpenter, in 1866. From 1878 through 1881, W. S. Taylor, Mrs. Guion, R. Farell, and L. Guthrie all rented house No. 3.

SCOTT RESIDENCE. In 1878, Dr. F. McComas, a teamster, rented this single-walled, two-story home, known as house No. 4. The home stands on a foot-wide brick foundation and includes a vaulted cellar. Robert Scott, a brick mason and the builder of New Almaden's Scott-Hüttner Furnace, resided in this four-room building in 1881. The first Scott furnace was put into operation in 1874 and was highly efficient at ore extraction.

HAUCK RESIDENCE, HOUSE NO. 5, 1903. The Thomas Barrett family rented this home in 1879. Fred Hauck Jr., bookkeeper for the New Almaden Quicksilver Mining Corporation, and his family resided in this house in 1915. Schoolteacher and justice of the peace, Theodore S. Shaw, rented the house in 1881. The brick sidewalk was restored to its original look and contains 20 different company-named bricks, hinting at the great amount of trade that occurred during the high-mining era. (Courtesy Bulmore family.)

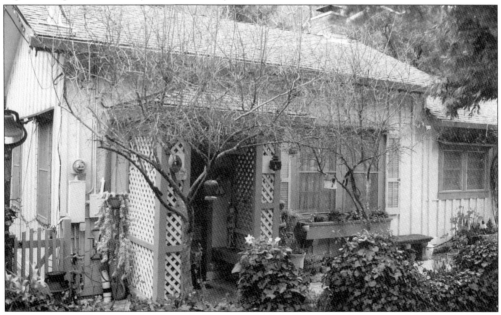

LA MARIPOSA. Known as the Butterfly House in English, house No. 6 was one of the first buildings to use Portland cement in its brick foundation, which was laid in 1852. Each of the two stories of this board-and-batten house was divided into two rooms. The home was built without indoor plumbing. Frank Bohlman, the mine company's sole contractor for running supply wagons on Mine Hill, rented the cabin in 1878.

EL VESPERO. The 1866 rent records show that "Whispering Wind," house No. 11, was a boardinghouse. Frank and Laura Bohlman, livery stable operators, rented the home in 1880. Oral history suggests the building housed the sheriff's office and jail, where local drunks sobered up in the back room. Once sober, they climbed out the window and returned to work. The site also included a blacksmith shop and barn.

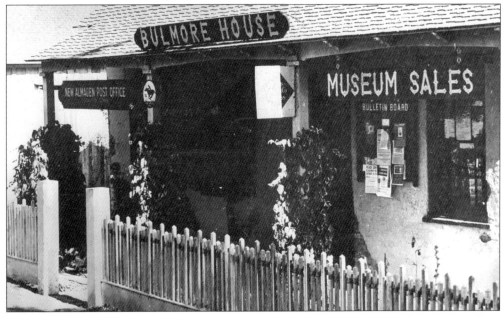

BULMORE HOUSE, 1960. Over the years, an accountant's office, private residence, post office, and museum sales store have been located in house No. 12. The rent roll of 1878–1881 shows that Robert R. Bulmore, accountant for the Quicksilver Mining Company, rented house No. 13 next door. He lived here, in house No. 12, from 1883 to 1895. Constance Perham purchased this building, and, in 1998, her son sold it to its present owner.

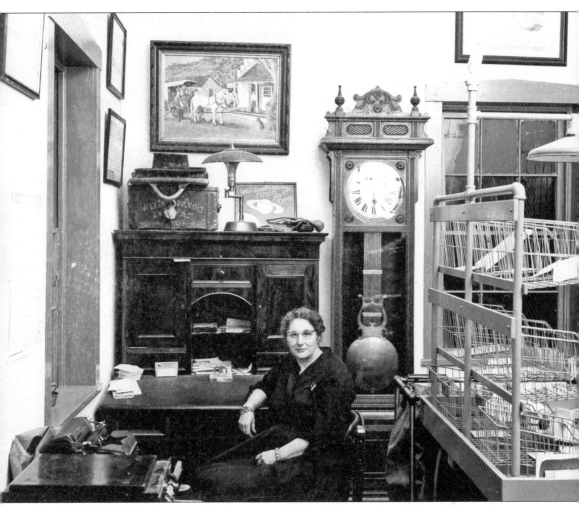

BULMORE POST OFFICE, 1960. Connie Perham took a break from her duties in 1960, while sitting at a desk, which had possibly been Governor Stanford's. She was proud of her antique collection, which included an original Wells Fargo strong box stored above the desk. Connie served as the New Almaden postmistress between 1960 and 1965. She worked with Jimmy Schneider and Lawrence Bulmore to established the New Almaden Historical Society, preserving many of New Almaden's historical artifacts from the mining era. She followed the tradition of several former postmasters from New Almaden who became respected civic leaders in the community: George Carson, Fred Hauck, Frank Pfeiffer, Gladis Cannon, Norman Pope, and Agnes Yuseff. Other former postmasters and postmistresses, starting from 1861, were John C. Brodie, Ralph Lowe, Ferdinand Fiedler, Maynard H. Harms, Jefferson F. Tatham, John W. Dubois, Charles H. Barross, Susan J. Peters, Angus C. Beckenridge, Mrs. Frank Thompson, Florence Pfeiffer, Gertrude Linehan, Beverly Adams, and Mary Ball. Today the New Almaden Post Office still operates in town and has its own zip code—95042.

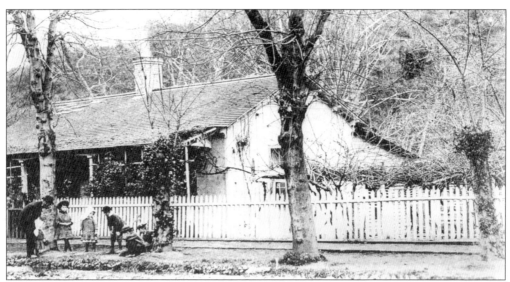

GEORGE CARSON HOUSE, C. 1885. The Carson children played marbles outside house No. 13. Until the mining company closed in 1912, George Carson held the position of postmaster, storekeeper, local Wells Fargo agent, and assistant company accountant while living in the home. The Perham Electronic Museum collection was housed in this building in the 1970s. (Courtesy Laurence Bulmore.)

NEW ALMADEN MUSEUM, 1955. In 1926, James and Adelaide Healey purchased a summer home, the Carson House adobe, house No. 13. In 1949, their daughter Connie, then owner of the home, opened the New Almaden Mining Museum in the back buildings, displaying collections of Native American and mining artifacts. In the front yard, she displayed a try-pot and demonstrated how early miners used a horse-drawn *arrastra* to crush cinnabar rocks.

ELLARD CARSON, 1902. The son of George Carson, the New Almaden postmaster from 1885 to 1903, Ellard Carson was a mining company surveyor between March 1900 and January 1903. Ellard grew up in New Almaden's house No. 13, attending Hacienda School in 1889, playing baseball with the Quicksilver Mining Company's team in 1890, and trying his hand at acting. The company trained him to become a mining engineer and a superintendent. (Courtesy Bushnell.)

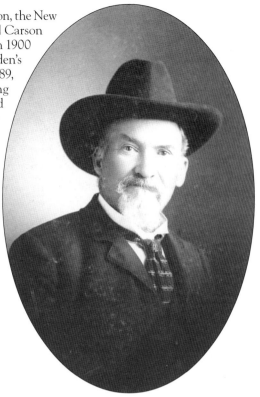

YOUNG NEIGHBORS, C. 1890. Posing in this garden photograph, from left to right, are Alanson Randol, son of Alanson Randol; Mary Carson, daughter of postmaster Ellard Carson; and Freddie Wolfe, nephew of mine superintendent Frederick Von Leicht. (Courtesy Harper Wright and the Randol family.)

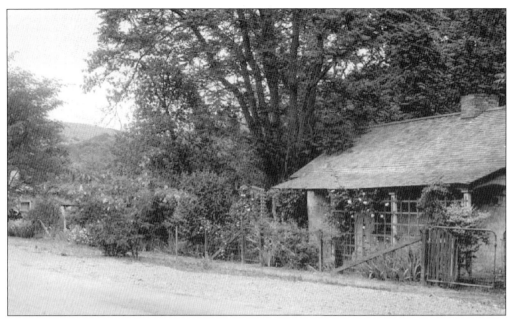

BUTCHER SHOP, 1936. The original butcher shed and a whale oil-rendering try-pot can be seen in the side garden of house No. 14. Early tenants of the home were William Fiederer, company store manager in 1865, and Captain Brenham in 1866, both partners with the Almaden Store. In 1926, Bert and Evelyn Kirk bought this 1850s two-room adobe and wood-frame house for their summer home. In 1936, Dr. West rented this home. (Courtesy Historic American Building Survey.)

LA CASITA ADOBE, 1996. In 1898, Dr. Frederick V. Hopkins, father of Dr. Mark Hopkins and pastor of the Methodist-Episcopal Church, rented house No. 15, El Adobe Viejo, a two-room adobe. Frederick was born in 1839 in Vermont and became a surgeon and professor of geology at Louisiana State University. He originated a method of killing bacilli of tuberculosis and leprosy. His wife, Annie Terhune, was James Randol's sister-in-law. (Courtesy Mike Boulland.)

DUTECH SALOON AND BILLIARDS. By 1858, Joseph Dutech (pictured here, *c.* 1850) rented "with privilege" a hotel, billiards parlor, and saloon from the Baron, Forbes Company. This "privilege" gave Dutech an exclusive monopoly to these businesses on company property. He owned house No. 16 but rented the land. Later he was proprietor of the New Almaden Stage Line and Livery Stable. Charles Garratt, a butcher, occupied the house in 1878. (Courtesy Ernest G. Kinney Collection, Sourisseau Academy, San Jose State University.)

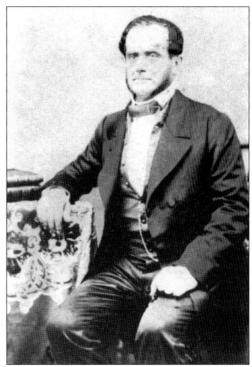

JUSTICE'S OFFICE AND VOTING PLACE, C. 1886. House No. 16 served as the town's court office and voting place in 1878. That same year, a voting scandal took place in New Almaden when the Republican candidate Charles N. Felton gave a large book of photographs, *Views of New Almaden*, to each voter. The Democratic candidate accused him of buying votes. In a heated trial, Felton was acquitted. By 1887, this building may have been a doctor's office.

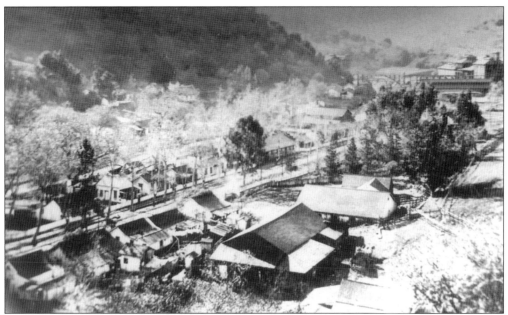

MINEWORKERS CABIN, C. 1902. Located, from left to right, on the far east side of Almaden Road, houses No. 17 through No. 24 were mostly rented to company employees. Laborers who rented house No. 19 throughout 1887 were Joaquin Yturriaga, August Villanuéva, Santiago Berryessa, E. Soto, P. Lofétèque, Manuel and Eliza Ysassaga, Joe Gonzales, and Jesus and Sabena Navarro. (Courtesy Bulmore family.)

PHYSICIAN'S OFFICE AND JUSTICE HOUSE, 2006. In 1863, Alvino Barrera rented house No. 18 with "privilege" to sell liquor, but in 1865, it may have been used as a butcher shop. In 1878, the home became medical offices for Dr. Smith E. Winn, Dr. J. Underwood Hall Jr., and others, as well as a justice house for Theodore Shaw, Alexander Innes, and George Lighthall. (Courtesy John Slenter.)

MISS WINNIE'S HOUSE, 1964. From 1867 to 1868, N. Banuelos rented house No. 20 from the Quicksilver Mining Company. Lucas Vielma, a laborer, and his wife, Juana, rented the home from January 1878 to May 1880. Another laborer, Jesus Navarro, his wife Sabena, and their family rented the house between 1880 and 1881. Seated on the porch is Mr. Ansel, brother of Winnie Ansel.

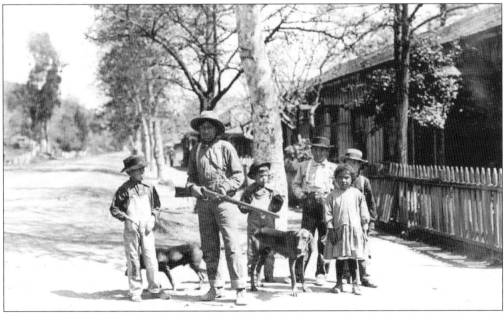

NEW ALMADEN RESIDENTS, C. 1912. At the end of Almaden Road, a man with a long rifle posed in front of house No. 22 with four young boys, a girl, and two hunting dogs. Between 1878 and 1881, John Hansell, A. Hodges, Thomas Miles, and Manuel Ysassaga were renters. House No. 22, located next to the company store, may have been demolished or relocated to the livery stable lots. (Courtesy Harper Wright and the Randol family.)

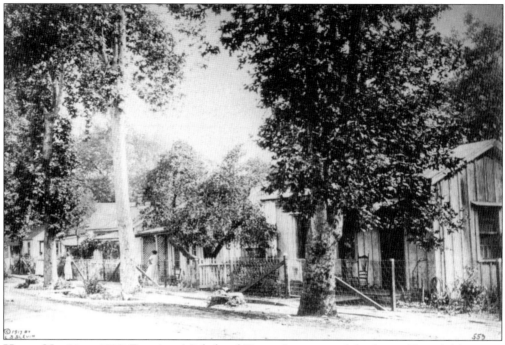

HOUSE NO. 21, C. 1919. Francisco Michel and George Lewis rented this house (far right) between 1865 and 1868. Carpenter and hotel manager Jefferson B. Baker along with his wife, Julia, rented the house from 1878 to 1879. Furnace foreman William Stiles and his wife, Julia Stiles, raised their three children there. The last person who lived on Mine Hill, from 1984 to 1986, currently lives in this house. (Courtesy California Historical Society.)

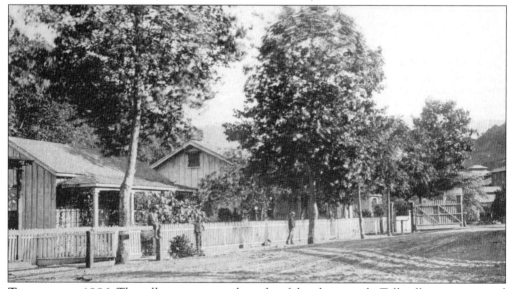

TOLLGATE, C. 1886. The tollgate is seen to the right of the photograph. Toll collectors inspected wagons and collected fees to pass the tollgate. The apartments seen to the left of the tollgate are labeled as houses Nos. 24 to 26. In the 1860s and 1870s, No. 24 and No. 25 were rented to Berryessa family members. Frank Lewis, husband of Patty Reed of Donner Party fame, lived in No. 26 in 1866. Antoñio Soto, a Mutsun Indian, rented No. 26 in 1880.

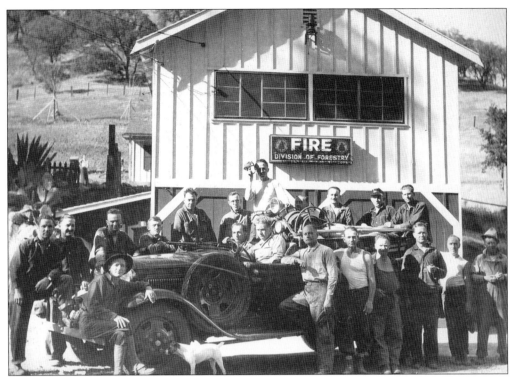

VOLUNTEER FIRE STATION, 1937. Community residents raised enough money to form a volunteer fire department, buy a fire truck, and build a garage to shelter it. Whenever fire broke out, volunteers turned out! Even though New Almaden no longer has to provide its own fire protection, everyone still turns out to help. Pictured is the Division of Forestry fire station.

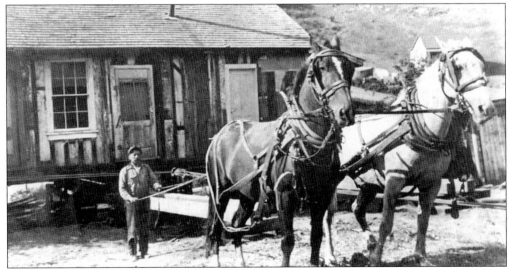

HOUSE MOVING DAY, C. 1900. Miners in the 1860s owned their cottages but not the land. When a miner quit, the Quicksilver Mining Company required that they leave with their home or sell it to the company. One miner, Mr. Beltrans, refused and the company disassembled his house and brought it to the edge of the property. Some houses were moved from Mine Hill to Almaden Road. (Courtesy Bulmore family.)

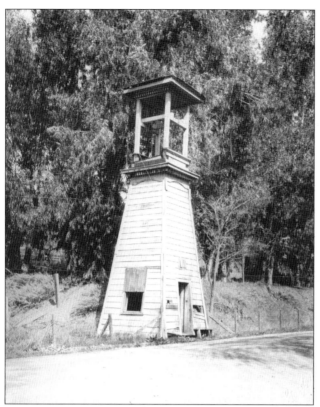

BELL TOWER, 1924. Following a major fire in 1875, James B. Randol installed fire hydrants in the Hacienda. The bell tower, which included a hose cart, was constructed on Almaden Road across from the Tollgate House and near the Hacienda Mine Works entrance. The tower was used to warn the residents and call the volunteer fire brigade into action. (Courtesy John Gordon.)

CACTUS HOUSE. In 1878, Adolpho Banales, a laborer, rented this two-room miner's cabin, house No. 30, for $5 a month. During the 1970s, two boys threw a prickly pear cactus on the porch roof, and it took root. Pictured here in 1988, from left to right, Marilyn Smith, Howard Broughton, and Carol Hodgins pose under the cactus. (Courtesy Howard Broughton.)

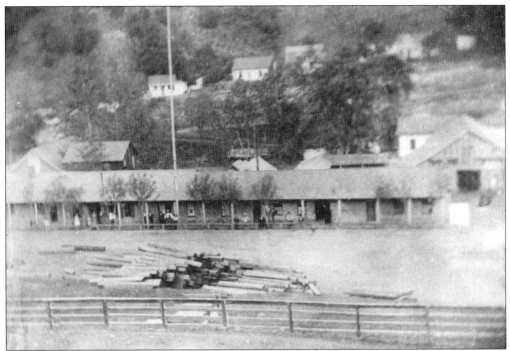

EARLY HOTEL. In 1875, the blacksmith shop and adobe boardinghouse, located at the entrance of the Hacienda Mine Works, caught fire while the town's residents were celebrating at the dance hall. Volunteers manned the pumps but a hose burst, causing the hotel to be lost. Later Randol offered a $1,000 reward for the arrest of the arsonist and authorized fire hydrants to be installed.

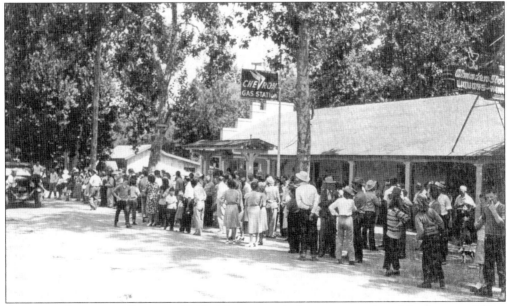

ALMADEN STORE AND PARADE, 1946. A large crowd of spectators gathered for the annual New Almaden Day parade that ended in front of the Almaden Store. This popular activity is now called the Jump-In Parade, where families and their children jump in after the Community Club Marching Band truck passes. They follow the music to the community club for festival events.

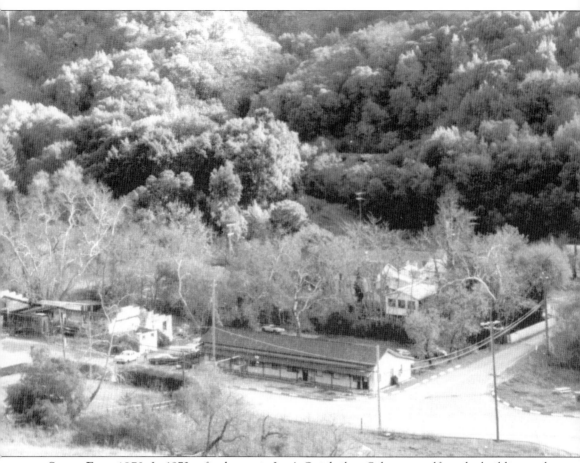

STORE FIRE, 1973. In 1973, a fire began in Lou's Quicksilver Saloon engulfing the building and destroying it. The 124-year-old adobe served the community as post office, bar, general store, apartment, gas station, and resident gathering place for many years. The burned shell stood until 1980, when a city bus crashed into the remaining walls, collapsing them. Here the journey ends at Bulmore Park on Almaden Way. A brick monument recognizes Luis Chabolla and Antoñio Sunol, who first worked the New Almaden ore. Eventually these men started a method where more than one million 76-pound flasks of quicksilver, valued in excess of $100 million, were processed from ore mined in the surrounding hills and transported past this location on its way to worldwide distribution. Today the stories told about the early pioneers who worked and lived in New Almaden, remind one of the hardships they endured and the important roles these families played in New Almaden and the development of the Santa Clara Valley. (Courtesy Peggy Melbourne.)

Five

BERTRAM ROAD

The name Bertram honors an early New Almaden resident, Richard Bertram Barrett, who lost his left arm at the age of 13 in a hunting accident. Bertram Road was first built in 1847 when workers added a bridge over Alamitos Creek, adjacent to the Tollgate House. This allowed access to the adobe boardinghouse called the Hacienda Hotel, which burned in 1875. Rebuilt as a wooden structure, it still stands today, having housed several restaurants over the years, including the Cafe Del Rio, New Almaden Food and Beverage Company, and La Forêt.

In the 1870s, James B. Randol built the Helping Hand Club, where employees and management socialized, read newspapers and books, played card games, and entertained from the stage. Many visitors rented the upstairs rooms, including George Broadhurst, a Broadway playwright. In 1943, Frank Pfeiffer disassembled the Helping Hand Club and built a home on the same location. Under the leadership of Nathaniel Gross, the New Almaden residents built a community club adjacent to the boardinghouse.

In 1899, Guadalupe Madera and the Quicksilver Mining Company built a new Catholic church called St. Anthony's, which continues to serve its members today. The present building replaced the earlier St. Anthony's Church that once existed in Spanishtown. The Hacienda Cemetery, established in the 1850s, was located at the end of Bertram Road, where the earliest known burials occurred in 1854 and continued beyond 1912.

Around 1928, the heirs of George Sexton subdivided the Hacienda area for development and actually bulldozed a road through the Hacienda Cemetery. New people arrived, many of them summer residents. A second bridge was added between the Hourét ranch and Casa Grande to link Bertram and Almaden Roads. In 1963, the U.S. Department of the Interior gave the community club the responsibility of caring for the newly established National Register Landmark District.

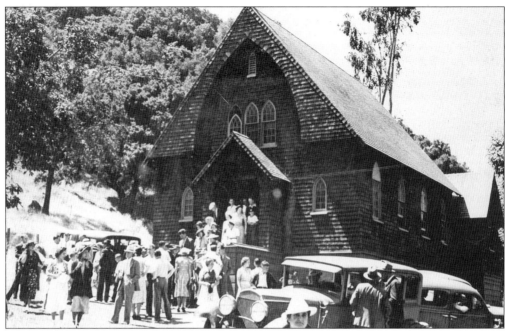

ST. ANTHONY'S CATHOLIC CHURCH, 1930. Guadalupe Madera's son Tony Madera volunteered for service in the U.S. Navy during the Spanish-American War (1898). Guadalupe vowed to build a church with the help of the mining company if he returned home safely, which he did. The church was constructed in 1901. Mrs. Madera ran a miner's boardinghouse for many years.

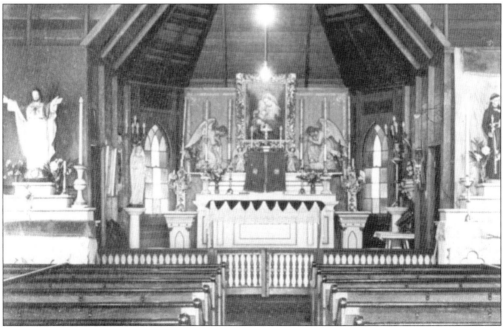

INSIDE ST. ANTHONY'S CHURCH, 1935. This altar is shown as it existed before remodeling. Some of the church artifacts may have come from the Spanishtown Catholic church up on the hill. In 1978, to modernize the church, the pastor removed the altar rail, seats, and large statues of angels, saints, and other religious artifacts shown in this photograph.

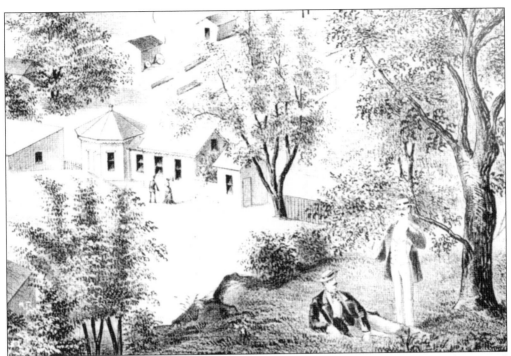

MINERAL SPRINGS. Along the banks of Alamitos Creek, Francois A. L. Pioche leased a natural flowing, bubbling mineral spring called Vichy Springs. He capitalized on the highly prized water by bottling it and building an octagonal well house in 1867. The popular bottled water was nationally advertised. At $1 for a dozen bottles, one could add carbonated water to the afternoon tea party. Pioche described that the water had healing powers to cure various illnesses and claimed, "the New Almaden Vichy Water is the most powerful adjuvant to remedies prescribed." The bottling of New Almaden Vichy water came to a halt in 1882 when miners working the Buena Vista Shaft punctured the spring's carbonation source. When the digging caused the bubbling water to turn flat, the California Vichy Water Company went out of business. After the mining work stopped, the flowing spring water returned. Today the carbonated bubbles can still be seen by looking into the creek from the Alamitos Bridge. (Drawing 1876, New Almaden Mining Museum.)

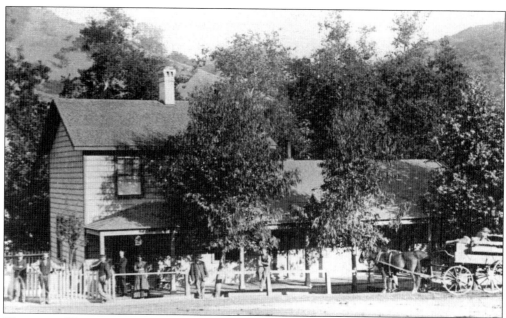

HACIENDA HOTEL, C. 1880. In 1848, the Old Adobe, California's first two-story adobe hotel and boardinghouse, was built to house mineworkers and visitors. Fire destroyed the building in 1875. It was replaced with a wood clapboard structure. The building continued to be used as a small hotel until the mine closed in 1912. Pictured above, the Smith family stood in front of this last building. (Courtesy Jimmy Schneider.)

CAFÉ DEL RIO, 1940. In 1934, owners Helen and Carl Resch converted the vacant Hacienda Hotel into the Café Del Rio restaurant. They stood behind the bar of their continental restaurant as diners enjoyed creek-side dining and views of the rambling creek. In 1979, the Reschs sold the business to Almaden Food and Beverage Company, and the following year, Johnny Davoudi leased the building and started La Fôret restaurant.

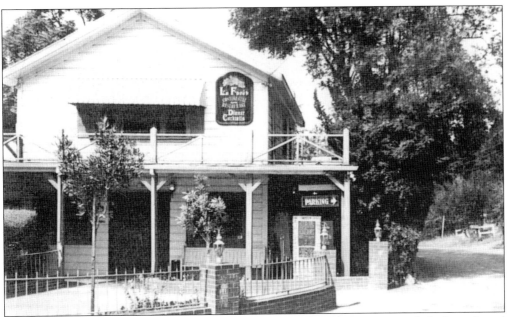

LA FÔRET RESTAURANT, 1993. In 1992, Johnny Davoudi, today's owner and chef, purchased the building and continued this successful establishment along Alamitos Creek on the same site that the Hacienda Hotel had occupied. Davoudi carries on the tradition of fine French dining. In the early 2000s, the *San Jose Mercury News* named this restaurant one of the best romantic dining rooms in the area.

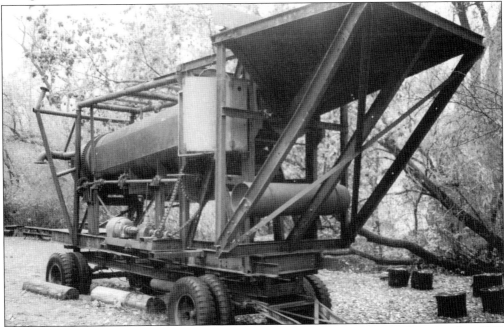

TROMMEL. When California Division of Mines mineralogist Walter W. Bradley visited in 1917, he said that the soil and gravel under the site of the furnaces was excavated to bedrock, a depth of 30 feet. The muddy gravel was slowly fed into this trommel, a washing plant for recovery of the metallic quicksilver. Ore was separated by size to increase the efficiency of the retorts.

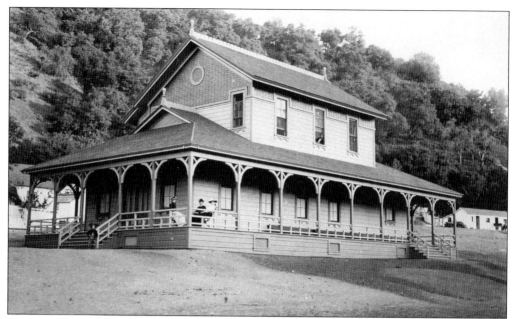

HELPING HAND HALL, 1890. In 1886, Giles McDougal built the Hacienda Helping Hand Club as a social meeting place for miners and their families. The large porch surrounded the front of the building; many residents gathered there in the summer. The stage in the clubhouse was designed with an incline from the front and was patterned after San Francisco's famous Tivoli Theater stage.

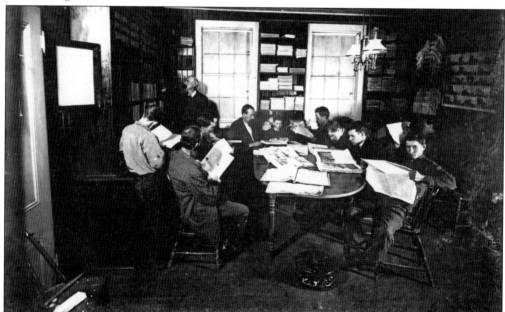

HELPING HAND READING ROOM, C. 1880. The building contained a library of books and newspapers, and miners were able to read after their long work shifts. The club became a popular gathering place due to its game room, kitchen, and large assembly and dance hall. The building's upstairs rooms were well furnished and were used for visitors' overnight stays. In the summertime, these rooms were used for arts and crafts classes for children.

NEW ALMADEN COMMUNITY CLUB, 1977. In 1924, the Almaden Improvement Club was formed to provide the community with a clean water system. After the name changed, this building was built in 1956, burned in 1982, and rebuilt in 1983. In 1977, members of the Air Force 682nd Radar Squadron stationed at Mount Umunhum, including Major Giles, Master Sergeant Fuller, Tech Sergeant Cuthbertson and Nancy Cotter, repair the roof. (Photograph by Tech Sergeant Neach.)

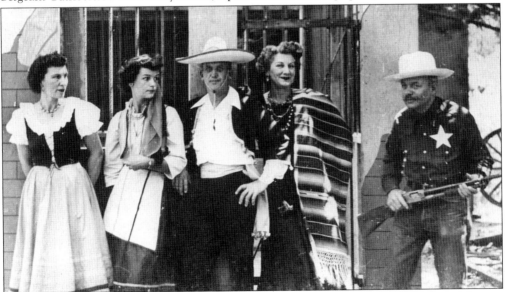

NATHANIEL GROSS. In 1949, Kitty Fields, an unidentified actor, Marion Austin, Florence Mooney, and Nathaniel Gross presented a Wild West play in New Almaden. Affectionately known as "Mayor Nat," Gross helped to build the New Almaden Community Club on Bertram Road in 1956, long after the Hacienda's Helping Hand Club was torn down. The building was named Nathaniel Hall in his honor.

REGISTERED NATIONAL HISTORIC LANDMARK, 1963. In November 1961, Charles W. Snell, historian with the U.S. National Survey of Historic Sites, requested that the New Almaden Community Club assume responsibility for protecting the historic integrity of the village. A bronze plaque recognizing New Almaden's historic significance was formally presented in 1963. Theron Fox and Laurence Bulmore stand behind the marker with former county supervisor Ralph Merkers.

PIONEER BRICKS. In the year 2000, a brick walkway and patio was dedicated during New Almaden Day. Etched bricks were cemented into the walkway and patio showing the names of people, businesses, and organizations important to the history of New Almaden.

FIRST HOME. The longtime resident and owner of this home claims it was one of the first built for the Lake Almaden Properties subdivision in 1926. Many cabins along Bertram's "back road" had their front porches enclosed for additional space and still have picket fences surrounding their yards.

CHINA SAM'S HOMESITE. Frederick Von Leicht's 1880 map of New Almaden shows several miners' cabins built on the east side of the creek. The rent rolls of 1878–1881 show that China Sam, Casa Grande's famous cook, rented house No. 40, a cabin near this site. These cabins have since disappeared.

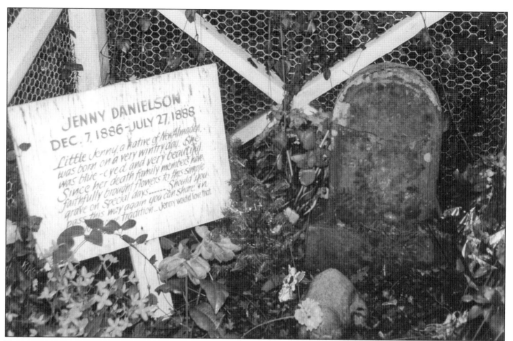

JENNY'S GRAVE. Visitors who come to the cemetery often leave Jenny Danielson's grave covered with fresh-picked flowers. Jenny was a little 18-month-old, blue-eyed baby girl who died of cholera. A sign at her grave asks all visitors to remember her with their prayers and flowers. Her mother, Josephine Danielson, married Judge Alex Innes.

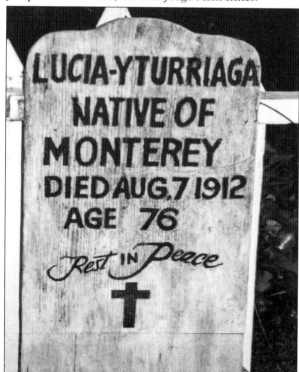

LUCIA YTURRIAGA. At 76 years old, Lucia Yturriaga is the oldest person buried at the Hacienda Cemetery. Her well-kept gravesite may be found on the creek side of Hacienda Cemetery. Her name, Yturriaga, means cascading water in Spanish. Lucia and Joaquin Yturriaga had six children. The oldest daughter, Beatrice, married Ignacio Smoot Sr., who worked in the mines as a stable boy, teamster, and coachman.

HIS ARM LIES HERE. The wooden grave marker of Richard Bertram Barrett provides a stopping point on a tour of the cemetery. A shotgun hunting accident blew off 13-year-old Bertram's left arm in 1898. Common practice and law of the day required his family give the arm a proper burial. The rest of him was buried at Oak Hill Cemetery. Barrett lived a vigorous life and died at the age of 74.

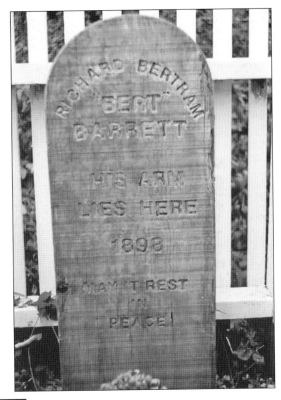

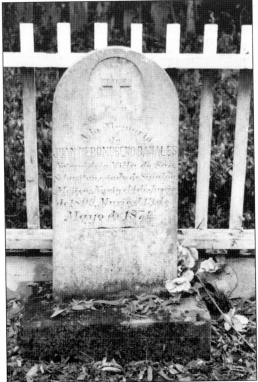

JUAN BANALES. Translated, the grave marker says, "To the memory of Juan Nepomuceno Banales, native of the village of San Sebastian, state of Sinaloa, Mexico, born the 4 of June 1809, died the 19 of May of 1871." Juan's daughter Josefina married Robert Richard Bulmore in 1880. When Josefina died, Robert married Emma Fowler, divorced her in 1887, and married Refugio, another daughter of Banales, who bore Laurence Bulmore in 1893.

BERTRAM ROAD CUT. Bertram Road divides the Hacienda Cemetery into two separate sections due to Ben Black's unauthorized actions. One night, in 1928, Ben Black cut a road through the middle of the cemetery. Residents could now drive their cars to the remainder of the house lots and return to Almaden Road on the North Bertram Road Bridge.

CARRIAGE TANK HOUSE. Next to the Hacienda Cemetery stands a board-and-batten redwood carriage and tank house dating back to the late 1800s. Oral history tells that the building behind Casa Grande may have been used as a stable or carriage house.

FISHING ALONG ALAMITOS CREEK, 1880. Robert Bulmore enjoyed fishing with his new bride, Josefina Banales. Trout and salmon fishing along Alamitos Creek was a popular outdoor sport throughout the year. A log allowed fishermen to cross the creek. After Club Almaden opened, fishing continued to be an attractive hobby here. (Photograph by Robert Bulmore.)

RIVER CABIN. The small resort cabins along Alamitos Creek housed vacationing residents and later were rented out to local residents. During the 1970s, Tiran Porter, who became a member of the Doobie Brothers band, lived in a cabin on Bertram Road. The band helped define California's pop/rock sound. Their albums of that era included *Toulouse Street*, *The Captain and Me*, and *Livin' on the Fault Line*.

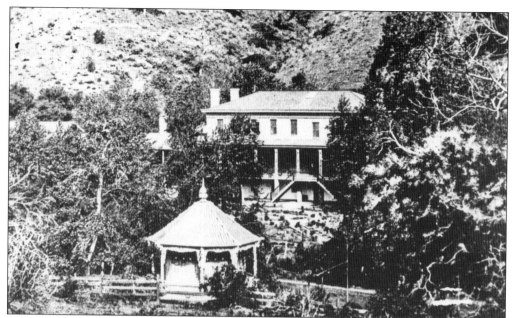

ORIGINAL SITE OF THE PAGODA, 1872. Chinese workers installed the pagoda on the east side of the creek five lots down the street from Hacienda Cemetery about 1858. In 1865, J. Ross Browne said, "A stroll through the gardens gave forth the most delicate odors of the flowers, a bath in the sparkling waters of the Alamitos, a pleasant saunter by the island and the Chinese pagoda." (Courtesy Bulmore family.)

LOG CABIN. In 1824, Joaquin Bernal settled in the Santa Clara Valley. His daughters married into the Sunol, Castro, and Berryessa families, all owners of land or mining shares in New Almaden. A Bernal descendant now lives in this cottage. In keeping with the charm of New Almaden, the owner acquired an ore car and well, thus contributing to the lovely home's front yard.

BAKER HOUSE. Standing in front of his rustic cabin, Wendy Baker is surrounded by many garden signs about pigs. Wendy has lived in New Almaden for over 50 years and allows his pet, Jimmy Dean, the famous "Dancing Potbellied Pig," to perform on occasion. His parents, previously owners of the cabin, ran the Playhouse and Coctauil Bar from 1961 to 1970.

DOLLHOUSE. Tucked in the front corner of the yard and hidden under a great oak tree, stands a delightful child's playhouse that looks like it's out of a Mother Goose fairy-tale book. Many homeowners have added buildings to give Bertram Road its unique country charm. The 1926–era cabins were not originally constructed with garages attached to the main home.

CHRISTMAS CABIN. This cabin, with its antique collection, always causes expressions of delight from children visiting New Almaden. The children love looking for the fantasy holiday antiques on display in the front yard. The 1940s home's collections have been continuously added to with new historical antiques.

WOODEN BRIDGE. One-lane Bertram Bridge, originally built in 1925 and rebuilt in 1956, crosses over Alamitos Creek as a wood-plank and steel-beamed bridge. One can view the cascading creek from the bridge.

Six

COMMUNITY LIFE

The Quicksilver Mining Company originally owned the land, homes, buildings, stores, schools, doctor's office, taverns, Helping Hand Clubs, and built the churches at the Hacienda and on Mine Hill in New Almaden. The company insisted on good behavior from residents but was paternal in their approach. They believed that a happy worker was a productive worker.

Spanishtown and Englishtown each had their own church. The Catholic church was built on a knoll overlooking Spanishtown. Father Picardie was the itinerant priest who served Spanishtown for several years. The Methodist-Episcopal Church was built on the top of a hill overlooking Englishtown. It collapsed after a year but was quickly rebuilt.

The Spanish school had one room with four grades. After the fourth grade, students attended the nearby school in Englishtown. A third school was located on Almaden Road. In addition, James B. Randol established technical schools in blacksmithing, carpentry, sewing, and cooking for both boys and girls at the Hacienda and on Mine Hill. During the summer of 1890, 146 students were enrolled. Those students who were punctual, exhibited good behavior and continued attendance were awarded prizes of $7 to $35.

During the Civil War, Dr. George Tolman organized the New Almaden Cavalry. It was based on Mine Hill until Samuel Butterworth banned weapons on company property. The men also formed societies, such as the Sons of St. George, and competed in the new sport of baseball with the nearby communities of Los Gatos and San Jose.

Entertainment was important among the residents. Fandango celebrations occurred on Catholic feast days, including the "Hanging of Judas" celebration held on the Saturday before Easter. Residents acted in plays at the Helping Hand Clubs, and everyone celebrated important U.S. holidays. Mine managers entertained regularly at Casa Grande. After the mining company went bankrupt, residents continued to celebrate at the playhouse, which was part of the old company store. The Black brothers, who were songwriters and wrote "Moonlight and Roses," constructed a dance hall as an addition to Casa Grande. Eventually this became the location of the "Opry House," which entertained county residents for many years.

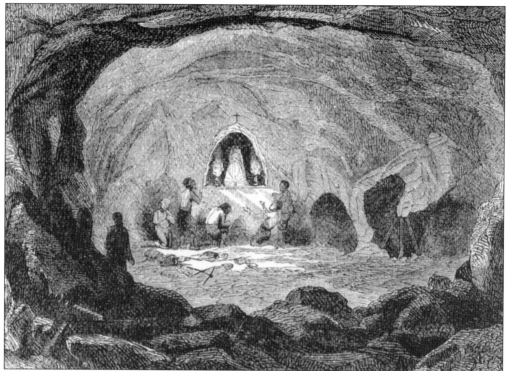

DEVOTION TO MARY, ENGRAVING C. 1857. A shrine to Nuestra Señora de Guadalupe in the recesses of the lower mine held a small figure where candles were constantly burning. The statue was clad in a handsome white gown accented by red morocco slippers, ornaments, and many headdresses. Before each shift, the miners would prostrate themselves, asking for protection against "fire-damps," "cavings," and sudden outbursts of water. (Courtesy *Harper's New Monthly Magazine*, June 1863.)

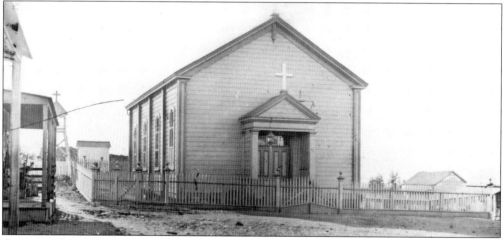

CATHOLIC CHURCH IN SPANISHTOWN, 1885. The first St. Anthony's Catholic Church, built about 1855 with community and mining company contributions, was located on the hill overlooking Deep Gulch and Spanishtown. It included stained glass windows, an organ, and a separate bell tower. Each Sunday morning, the vibrant tone of the bell could be heard throughout the hills and ravines. (Photograph by Robert Bulmore.)

HIDALGO CEMETERY IN SPANISHTOWN, C. 1935. A lone grave marker graces the Hidalgo Cemetery on Mine Hill near Spanishtown. In the 1930s, remains were moved to Oak Hill Cemetery in San Jose. The cemetery is still maintained because of the belief that those who had no grave markers are still buried there. There was a second cemetery nearby called the Guadalupe Cemetery.

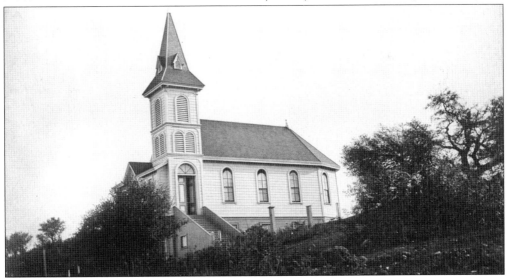

METHODIST-EPISCOPAL CHURCH, 1885. The church was built in 1871 overlooking Englishtown. Members rebuilt it in 1875 after it blew down in a windstorm. Henry Tregoning was the local preacher and his wife, Emma Morcom Tregoning, was the organist. After the church burned down in 1884, this church was built. A parsonage was built for the Reverend Mr. Milne. In 1885, 165 people attended Sunday school. (Photograph by Robert Bulmore.)

NEW ALMADEN RIFLE CLUB, C. 1885. Many mine employees won top honors in the rifle club. Pictured, from left to right, are Howard Derby; Charles C. Derby, mine superintendent from 1895 to 1900; J. W. Wilkerson, mine surveyor from 1887 to 1893; John J. Miller, company clerk in 1893; Robert R. Bulmore, mine manager from 1895 to 1900; Robert Scott, originator of the Scott furnace; David Bulmore; Neil T. Anderson, Almaden Store meat market proprietor; and Thomas Derby, mine manager from 1900 to 1909. (Photograph by Robert Bulmore.)

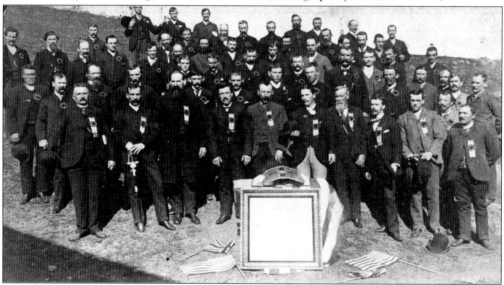

SONS OF ST. GEORGE, 1880. Members of the General Gordon Lodge, No. 286, assembled for this special photograph. Most of the members were from the rugged shores of Cornwall. Other societies in New Almaden included the Knights of Pythias Lodge and the Good Templar's Lodge, which was organized on April 2, 1883, and met in the basement of the Methodist-Episcopal Church in Englishtown. (Photograph by Robert Bulmore.)

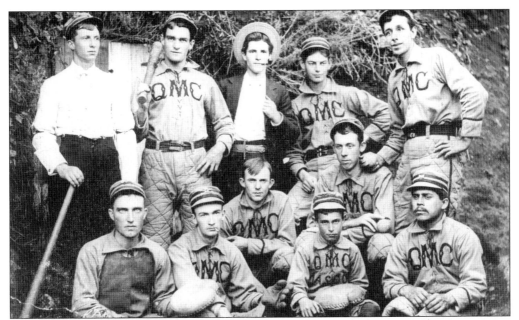

BASEBALL IN NEW ALMADEN, 1895. There were several organized baseball teams in New Almaden, including the Quicksilver Mining Company team, organized in 1891. Baseball games were played on the Hacienda School grounds with visiting teams from surrounding townships. Uniforms were first used in 1894. The catcher is seated at the left. Standing second from the right is Ellard Carson.

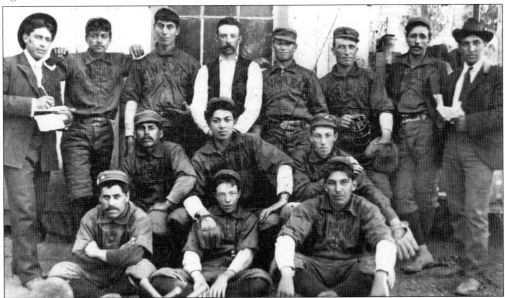

CINNABARS BASEBALL TEAM, 1900. Ten of the ballplayers are Nick Robles, Jim Fiedler, George Bulmore, Bud McCracken, Al Acevedo, Jack Carr, Dave Bulmore, Herman Skinner, Cuyie Mercado, and Tommy Ynostrosa. While describing the game against the Haciendas, Robert Bulmore said, "The queer capers of the professionals are too numerous to mention, yet now and again they showed the audience how baseball can be played." (Photograph by Milton Lanyon; courtesy Bulmore family.)

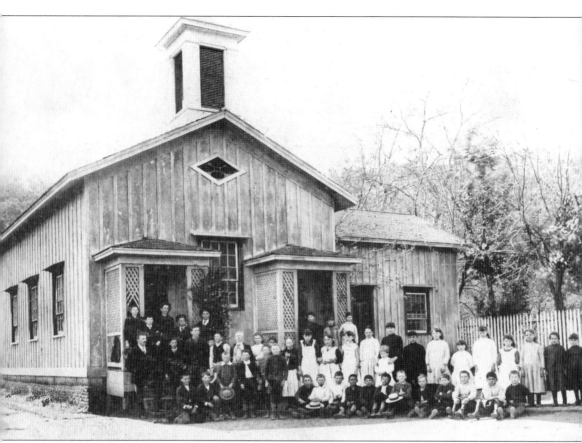

HACIENDA SCHOOL, CLASS OF 1889. This class had two teachers and 49 students from grades one through eight. The principal, Albert Schumate, is standing at the lower left. Pictured, from left to right, are (first row) Alfie Quevas, Frank McComas, John Busso, Ellard Carson, unidentified, unidentified, Fern Lawler, Will Masten, unidentified, Quevas, unidentified, Joe Contera, Carrie Lawler-Structing, George Martin, unidentified, Jack Carmar, Henry Dahlgren, George Gonzales, and Pete Barrett; (second row) Albert Shumate (principal), George Carson, Will Lawler, unidentified, Jerry Cannon, Ed McComas, Grace Hamilton, unidentified, Ella Limby, Jimmie Cannon, Rose Robles, Lily Barrett, Anne Buzza (Mrs. George Bulmore), Eva McComas, Mabel Buzza, Phoebe Barrett, Maggie Lawler, Marie Robles, Teresa Lawler, unidentified, Lily Buzza, Blanche Barrett, unidentified, Rita Banales, and unidentified; (third row) John Hancock, Jim Carson, and George Bulmore; (fourth row) John Stiles and Joe Cannon.

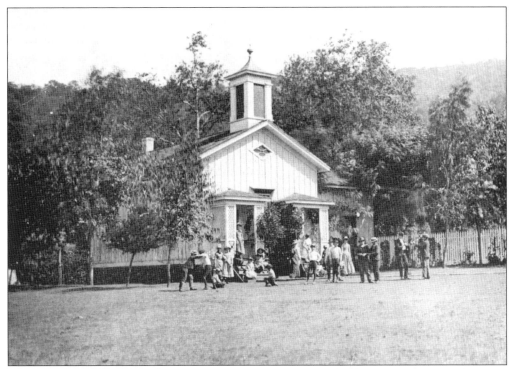

THE ORIGINAL HACIENDA SCHOOL, C. 1886. In the 1850s, the Barron, Forbes Company built the original Hacienda schoolhouse north of Casa Grande on Almaden Road to educate children of the mineworkers. Children from nearby ranches also attended. About 85 children attended grades one through eight. The school was demolished around 1914 but replaced later.

C. D. McGENORE, SCHOOLTEACHER, C. 1886. A teacher at the Hacienda School, C. D. McGenore gave this photograph of herself to two of her students, Garry and Willie Randol, and wrote, "For my dear boys Garry and Willie from their loving teacher." (Courtesy Wright's Art and Portrait Gallery, San Jose, California.)

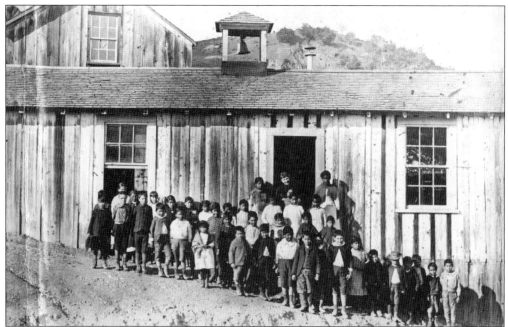

GRADE SCHOOL AT SPANISHTOWN. One schoolteacher, in the doorway, educated 38 children in the first through fourth grades at the Spanishtown school. The school was established primarily for those who spoke only Spanish. After the fourth grade, students went to the Mine Hill School in Englishtown. (Courtesy Pfeiffer collection.)

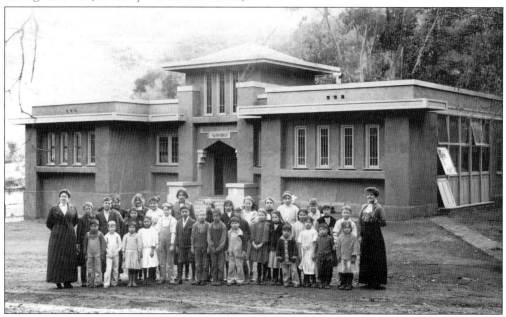

HACIENDA SCHOOL, CLASS OF 1918. When the original Hacienda School closed, a new one was built on the same property and dedicated in 1918. Gertrude Rule Sperring (1902–2000), great granddaughter of Capt. James Harry, is the tall girl standing in the back row, fourth from the right. The school was demolished in the 1930s before Paul Hourét built his home on the site. (Courtesy Sperring family.)

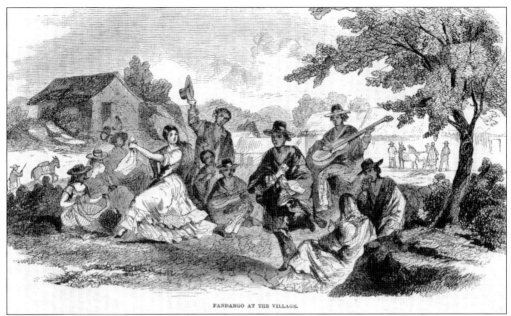

FANDANGO ON THE HILL, C. 1857. Spanish workers often celebrated their religious and civic holidays with singing and dancing in Spanishtown. According to author W. V. Wells in the June 1863 issue of *Harper's New Monthly Magazine*, "Sometimes on Sunday they get up a spirited dance. After a day of cigars, bad brandy, horse-racing, fandango and Monte, they break up with a general stampede on horseback and the village subsides into its usual quiet."

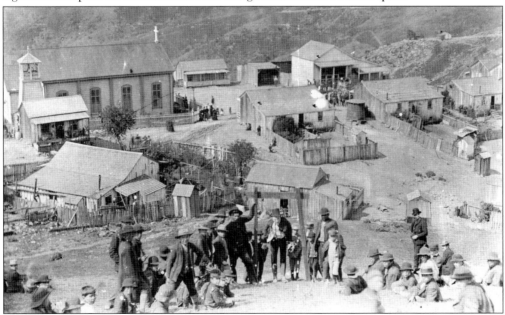

COLGANTE DE JUDAS, C. 1895. It is believed that Judas hanged himself on the Saturday after the crucifixion of Christ. The Mexicans paraded an effigy of Judas through Spanishtown, ending at this platform. After the crowd gathered around, they strung up the effigy, filled with fireworks and a cat. Once the fireworks were lit, the frightened cat was released, symbolizing the release of Judas's soul. (Courtesy Pfeiffer collection.)

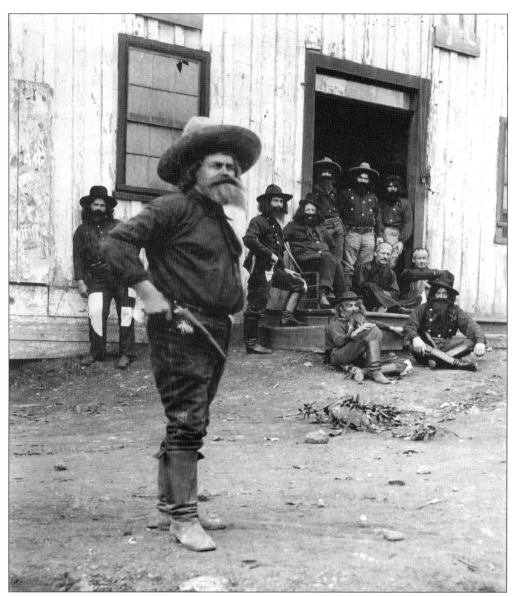

A "HARD TIME" PARTY, C. 1890. Mexican workers originally set up a theater in 1854 on Mine Hill. In 1863, Swain's Troupe from Monterey performed plays there. Later the Quicksilver Mining Company built three Helping Hand Clubs where miners relaxed from the rigors of mining and furnace work. The miners themselves were often ready to act in plays at the Helping Hand Club after the stage was built. Some performers who received wide acclaim were Florence Grey and Leone Hopkins, both teachers; Robert R. Bulmore, company clerk and then mine manager; George Wilkinson, surveyor; and George Carson, postmaster. Sidney Jennings and his wife often took part in plays while they worked in New Almaden. Hennen Jennings, Sidney's brother, was mine superintendent from 1883 to 1887. Pictured, from left to right, are (standing, foreground and by building) Reys Barraza and Richard Harry (mine captain); (first row) Ellard Carson and Dr. F. S. Lowell; (second row) Richard J. (Dick) Pierce and William H. (Harry) Pearce; (third row) Charles C. Derby, Charles F. O'Brion (in chair), Tom Wasley Jr., Thomas Wasley Sr. and Judge Alex (A. C.) Innes. (Photograph by Robert R. Bulmore.)

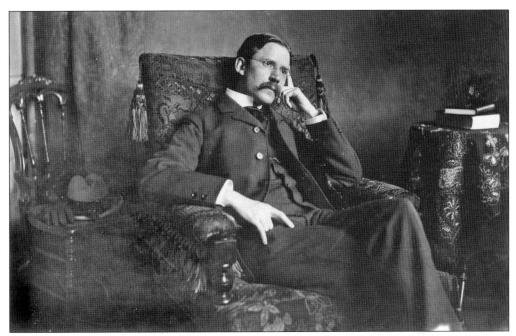

GEORGE BROADHURST, 1896. A prominent playwright and owner of the Broadhurst Theater in New York, George Broadhurst vacationed at New Almaden in 1896. During his stay at the Hacienda Helping Hand Club, Broadhurst wrote the comedy *What Happened to Jones*, which later enjoyed popular merit when presented in New York. (Photograph by Robert Bulmore.)

WAGON STAGERS.
Norman Pope, owner of the Casa Grande in 1951, leased an open area behind the building as an outdoor stage to a group of entertainers. The sign in front of Casa Grande during summer productions proclaimed: "New Almaden Theatre Under the Stars, Home of the WAGON STAGERS, Melodrama and Olios on our Outdoor Wagon Stage." Playing during the summer of 1964 were *M'Liss* and *King of the Gold Rush*.

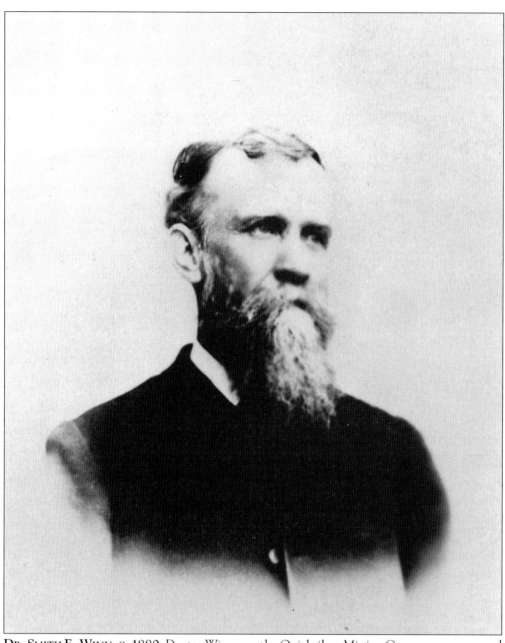

DR. SMITH E. WINN, C. 1880. Doctor Winn was the Quicksilver Mining Company surgeon and physician from April 1878 to 1889. He was paid $350 per month through the Miners' Fund, which itself was funded from $1 monthly payments by the mineworkers. He replaced Dr. Albert Richards Randol (1842–1876). Doctor Winn lived in Englishtown, made house calls in the morning and received patients at dispensaries on Mine Hill and at the Hacienda in the afternoon. During his tenure, Doctor Winn recorded 80,000 visits, either to his office or to miners' homes. He reported seven fatal accidents and nine cases of salivation during this period. As a photographer, he and Robert Bulmore developed a system for underground photography. In 1889, when he suffered a mental breakdown, mine manager James B. Randol sent him to Lake Tahoe to recover at his full salary. (Courtesy Bulmore family.)

Dr. J. Underwood Hall Jr. (1868–1946).
Dr. Hall served New Almaden from 1889 to
1894 with a salary of $250, including horse
and house. In 1899, he became president
of the O'Connor Sanitarium staff. In 1945,
when informed that he had cancer, he said,
"It's not contagious. I can still help others."
Pictured, from left to right, are Marion Hall,
Dr. Underwood Hall, Marshall Hall, and the
doctor's wife, Grace Spencer. (Courtesy
Hall family.)

Medical Uses of Mercury, 2006. A well-
known pesticide and germicide, mercury
was used to sterilize medical instruments.
During the Lewis and Clark expedition,
the party used mercury in ointment form to
cure syphilis. During the 1850s, Abraham
Lincoln took a "blue" mercury pill to cure his
melancholia. A mercury compound is still
used today as a germicide in many vaccines.
(Photograph by Arthur Boudreault.)

DR. W. T. JAMISON, 1903. After Dr. Winn left New Almaden in 1889, Dr. Underwood Hall Jr., who at age 17 had worked as a druggist for Dr. Winn, became the company doctor at a monthly salary of $250. Dr. Lowell followed him as the company doctor when he left in 1902. Dr. Jamison worked from 1903 to 1910 for a salary of $100 per month, possibly part-time.

DR. MORGAN DILLON BAKER (1880–1939). Doctor Baker served the New Almaden community from 1907 to 1910. He worked part-time and was paid from the Miners' Fund. Later he became a pioneer radiologist at O'Connor Hospital in San Jose and became the chief of staff in 1928. Dr. Baker, who replaced Dr. Mark Hopkins, who also served in New Almaden at O'Connor Hospital, died of radiation burns.

Seven

HACIENDA MINE WORKS

In 1846, William G. Chard experimented with gun barrels and then added six try-pots to reduce cinnabar into mercury. This was inefficient, but Castillero didn't have the capital to increase production. Gun barrels and try-pots were called retorts because fire indirectly heated the cinnabar to create mercury vapor.

In 1847, when the Barron, Forbes Company took ownership of Castillero's shares, they hired Robert Walkinshaw as superintendent and added several batch-type furnaces to increase production. Walkinshaw's furnaces were huge, each built using over 200,000 bricks. A furnace is different from a retort in that heat is directly applied to the cinnabar ore. A source of heat is required to convert the ore into mercury vapor and a cooling section is required to return the mercury to liquid form. While cool, workers filled each furnace with up to 35 tons of ore. A wood fire heated the ore. Then the furnace cooled and the spent ore was removed. This process took about eight days.

Walkinshaw built 14 furnaces that each used 700 cords of wood and up to 4,000 flasks of mercury per month. During the Civil War, the revenue was almost $2 million per year. The New Almaden Mining Company and the Quicksilver Mining Company contracted with or employed over 1,600 men during the period of the 1860s and 1870s.

After the Quicksilver Mining Company purchased the mines in 1863, the company built several chimneys on the hilltops to remove the pervasive smell of sulphur in the valley. When James B. Randol became mine manager, he commissioned H. J. Hüttner to design continuous furnaces similar to those used in Idria, Austria; Robert Scott built them. This reduced labor costs and reduced roasting time to 24 hours.

After the discovery of the cyanide process to recover gold in the 1890s, the demand for mercury lessened. Within 20 years, the Quicksilver Mining Company sank into bankruptcy and most of the Hacienda Mine Works was dismantled and sold. During the 125-year life of the mines, the mining companies processed over one million flasks of mercury.

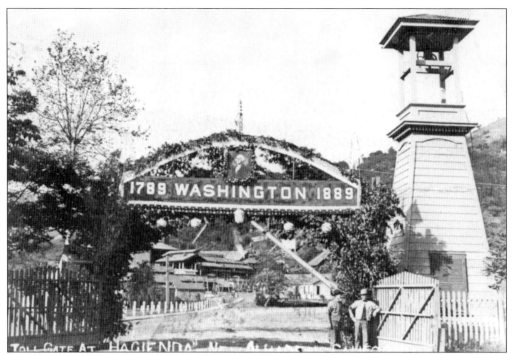

ENTRANCE TO HACIENDA MINE WORKS. The tollgate kept undesirable elements off the mine property. Flora Alice Martin, who lived at the Tollgate House, checked everyone as they came through the gate. Miners buying goods elsewhere were fined. In 1889, James B. Randol decorated the tollgate arch for the celebration of the centennial of George Washington's inauguration as president. The Hacienda Band, riding a wagon pulled by six white horses, led the parade.

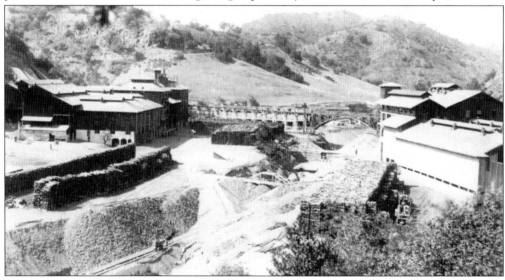

HACIENDA MINE WORKS, 1876. Ore processing was done at the foot of Deep Gulch on an 11-acre parcel. The mining company built furnaces on both sides of Alamitos Creek, an office, a blacksmith shop, and a carpenter shop. A rail trestle carried ore cars to the sorting area, left, and to the furnaces. The furnaces required up to 700 cords of wood per month. (Courtesy John Slenter.)

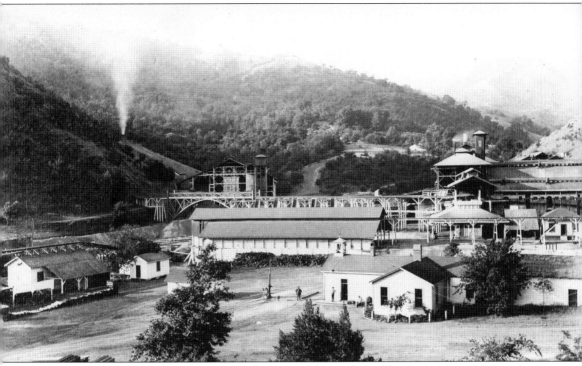

HACIENDA MINE WORKS, C. 1880. Looking south toward the Hacienda Mine Works, the Scott furnace on the left side of Alamitos Creek is behind the rail trestle. The blacksmith and machine shops are at the lower left. The storage shed, center, was used to store cinnabar and *tierra* bricks during the dry season for roasting in the rainy season. The mine office and other furnace buildings were on the right. To the right of the furnaces was a huge sorting shed, where ore was sorted into *gruesso* (ore highly charged with mercury), *granza* (ore with smaller concentrations of mercury), and *tierras* (ore dust and small particles). Each type was placed into different furnaces developed specifically for that type of ore. James B. Randol was aware of furnaces at the Idria mines in Austria that were designed for continuous operation. The first continuous furnaces were put into operation at the Hacienda Mine Works in 1874. Several more were built because they substantially reduced the cost of processing.

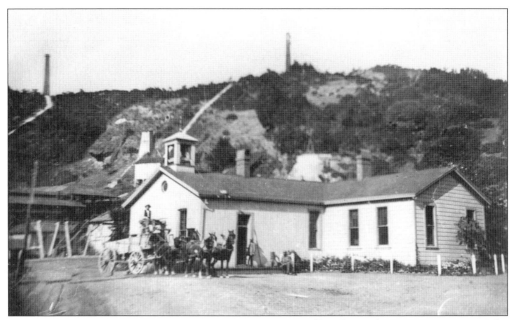

HACIENDA MINE WORKS OFFICE, 1880. As soon as Castillero began his operation in 1846, he established a site on level ground near Deep Gulch. When the Quicksilver Mining Company built this office, managers and office personnel could observe ore deliveries, as well as workers and visitors when they arrived. Tall chimneys in the background carried the sulphur fumes off the valley floor. (Photograph by Robert Bulmore.)

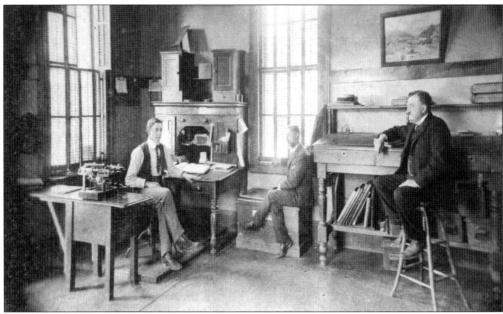

MINE OFFICE, C. 1880. The Hacienda mine office was the nerve center of financial activity for the Quicksilver Mining Company. Among other duties, management could watch flasks of mercury as workers stacked them alongside the office. Seated in the mine office, from left to right, are Adolph Wiener, company accountant; George Carson, postmaster; and Joe Harris, mine superintendent. (Photograph by Robert Bulmore.)

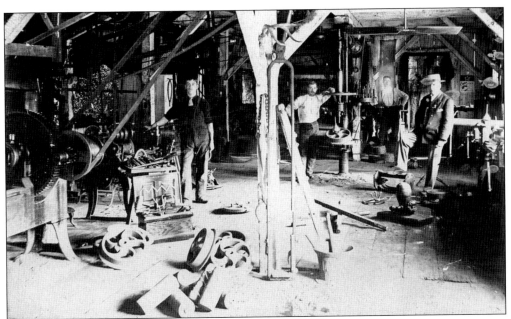

HACIENDA MACHINE SHOP, C. 1890. The machinery on the left was attached via a pulley to a common shaft and driven by a waterwheel. Water stored in a tower on Mine Hill near the head of Deep Gulch was released when power was required. After turning the waterwheel, the water poured into the *acequia*. Several iron wheels for ore cars were repaired here. Robert Richard Bulmore is at the right. (Courtesy Beverly Bulmore.)

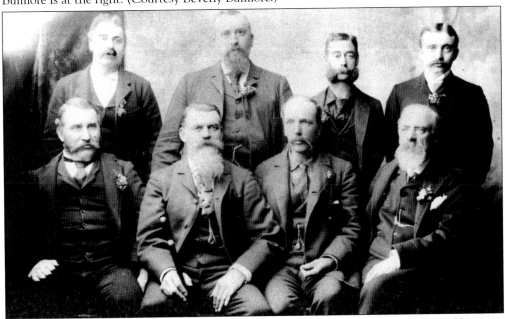

MINING COMPANY OFFICIALS, C. 1892. Pictured, from left to right, are (first row) James Harrower, chief engineer; Capt. James Harry, senior mine foreman and mine manager from 1892 to 1895; Robert Richard Bulmore, cashier, clerk, and mine manager from 1895 to 1900; Charles O'Brion, *planilla* foreman; (second row) Adolph Wiener, accountant; John H. Bohlman, roadmaster; George Carson, postmaster; and James Wilkerson, surveyor. (Courtesy Bulmore family.)

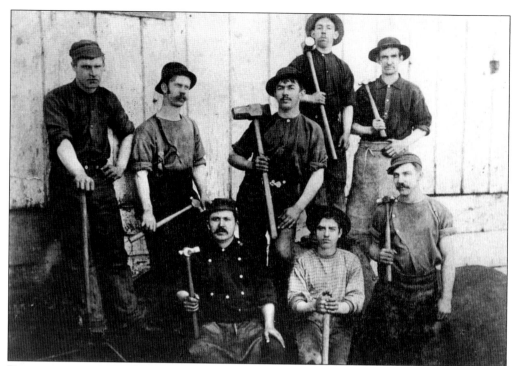

BLACKSMITHS AT THE RANDOL SHAFT. Blacksmiths were essential to the operations of the mines. They worked at the Hacienda and at each mineshaft, repairing drill bits and hoisting machinery, rails, and ore cars. During a flood at the Hacienda in late 1864, C. E. Hawley wrote, "One blacksmith rushed out as a torrent broke into the shop and called vociferously for picks and shovels or a life boat." (Courtesy Bulmore family.)

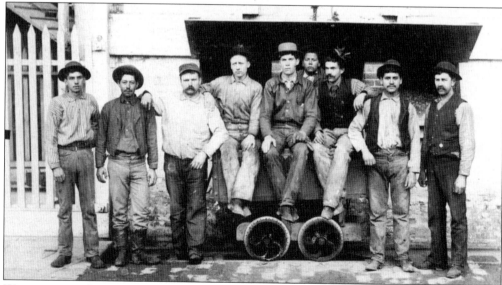

WORKERS AT A SCOTT FURNACE, 1897. Furnace workers sorted cinnabar into three sizes of ore. They loaded furnaces and removed spent ore from the chambers. Others collected mercury from the condensers and filled flasks to 76.5 pounds each. Since the serious effects of breathing mercury fumes were well known, both management and workers took precautions to avoid salivation.

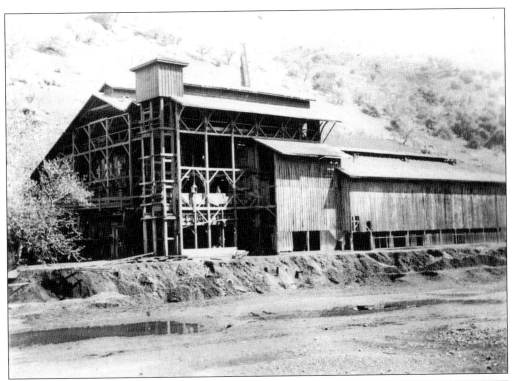

SCOTT FURNACE, C. 1890. After James B. Randol became aware of continuously operating furnaces at the Idria mines in Austria, he engaged H. J. Hüttner, a mechanical engineer, and Robert Scott, a brick mason, to design and build a comparable furnace. The first furnace was put into operation in 1874 at the foot of Deep Gulch. After the success of this one, Randol added several more. (Courtesy Schneider collection.)

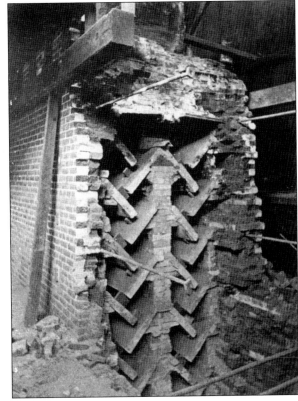

SCOTT-HÜTTNER CONTINUOUS FURNACE NO. 3, C. 1885. Workers dropped ore into three columns. It was filtered down and filled the opening. As the ore roasted, workers removed spent ore from the bottom. This furnace held 51 tons of ore at a time and had a charge time of 34 hours, using 2.5 cords of wood every 24 hours. In 1882, three men working three 12-hour shifts were paid about $11 for a charge.

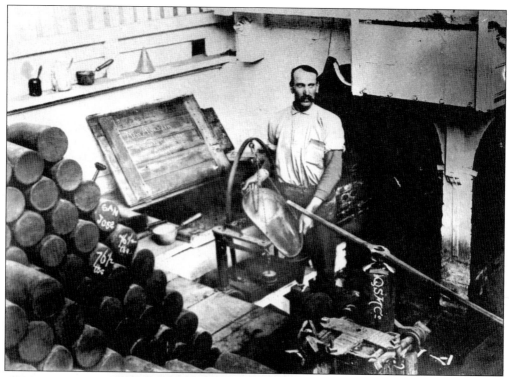

FLASKING MERCURY, C. 1894.
Andrew Dahlgren carefully weighed mercury on a scale and ladled additional metal into or out of the container until the correct weight, 76.5 pounds, was reached. Then he poured mercury into a flask and sealed it with a screw cap. The Romans originally determined the size of a flask, which in Roman terms was called 100 *quintals*.

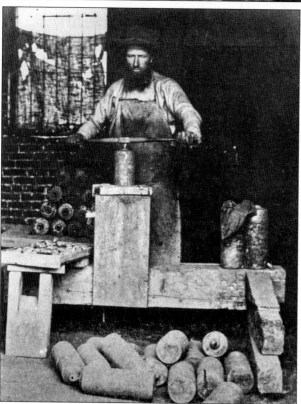

REPAIRING FLASKS, C. 1877.
Blacksmiths reground the threads of flasks before their reuse to assure there was no leakage of mercury when the company shipped the flasks. They were then painted with the weight and the letter A within a circle, the Quicksilver Mining Company brand. For many years, Thomas Bell, a San Francisco businessman, was the exclusive sales agent for the Quicksilver Mining Company.

INCLINE RAILROAD, C. 1890. Sherman Day designed and built this incline railroad in 1858 to decrease the cost of transporting ore to the furnaces. A car full of ore traveled down while an empty one returned. Once, two mineworkers were repairing the line and rode the car to test their work. The line snapped and they were killed. Since company policy forbade this practice, their families were not compensated.

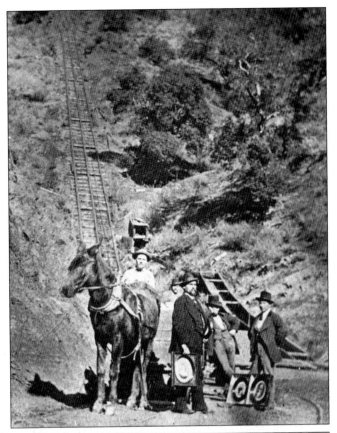

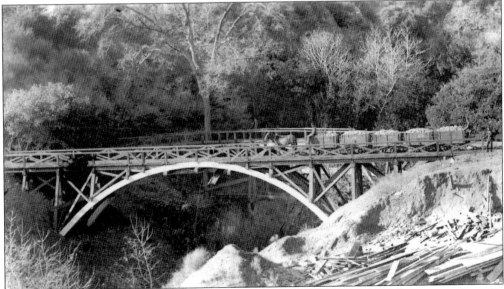

BRIDGE ACROSS DEEP GULCH, C. 1885. Ore from Mine Hill traveled by rail in ore cars from the mine entrance, down the hill on the incline rail, and across Deep Gulch Creek to the *planillas* (sorting sheds) at the Hacienda. Each car was filled with a ton of ore. (Photograph by Dr. Smith E. Winn; courtesy Bulmore family.)

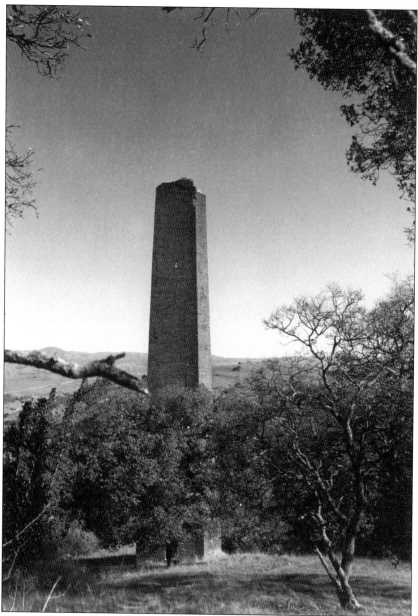

CHIMNEY AT HACIENDA MINE WORKS, C. 1983. Heating cinnabar in the furnaces at the Hacienda created a steam of mercury and sulphur. Sulphur didn't recombine with mercury when cooled because the workers added lime to the ore. This allowed mercury to precipitate first. Sulphur then continued up the chimney, resulting in the familiar "rotten egg" smell that permeated the Hacienda settlement. After the Quicksilver Mining Company purchased the mine works, engineers added six chimneys high above the mine works on both sides of Alamitos Creek beginning in 1865. Since it was difficult to regulate the heat applied to the ore below, mercury often would remain in a gaseous state and go up the chimney. Miners would occasionally scrape the interior walls of the chimneys to remove and process mercury-laden soot. Still standing, this last chimney is over 100 feet high, with an interior opening six feet in diameter. This chimney is several hundred feet above the Hacienda, just south of Deep Gulch, and has survived many major earthquakes.

Eight

MINE HILL

Castillero's workers mined the Indian Cave. The Barron, Forbes Company hired several hundred miners to follow the ore body down into Mine Hill. *Tanateros* carried 200 pounds of ore on their backs up the *escaleras* (narrow ladders) to the mine entrance and repeated this 20 times a day. Ore was sorted into *gruesso* (high grade ore), *granza* (lesser grade ore), and *tierra* (small particles and dust). *Tierra* was brought to the Hacienda Mine Works where these particles were mixed with clay and made into bricks that were roasted during the winter. Ore was also stored in sheds so that furnaces could operate during the rainy winter season. Horse and mule teams were the primary way to transport ore. Barron, Forbes Company added the main tunnel below the Indian Cave. This allowed workers to drop ore down to the ore cars. Sherman Day designed and installed an incline railroad that reduced the time it took to bring ore to the furnaces.

The earliest workers built shacks along the sides of the hill near Indian Cave. Barron, Forbes Company constructed new buildings, creating Spanishtown. Cornish workers lived in Englishtown. Both communities had a mine office, a school, a general store, a church, and a doctor's office.

Bull Run Mine opened in 1863 and the American Shaft was sunk in 1864. James B. Randol commissioned several shafts. The Randol Shaft, sunk in 1871, was the most productive. Others were the Santa Isabel and St. George in 1877, the Cora Blanca and Victoria in 1880, Washington Garfield in 1881, and the Buena Vista in 1883. Captain Harry sank the Harry Shaft in 1893, and George Sexton financed the Senador Mine in 1916. The deepest point was 2,300 feet below the summit of Mine Hill and over 100 miles of tunnels were dug.

During the 1930s, workers from the Works Progress Administration (WPA), while living in Englishtown, removed abandoned homes and buildings. In the late 1930s, a new 35-ton rotary furnace was installed at Spanishtown. Mining continued intermittently until 1976, when the New Idria Mining and Chemical Company of Fresno sold the property to Santa Clara County.

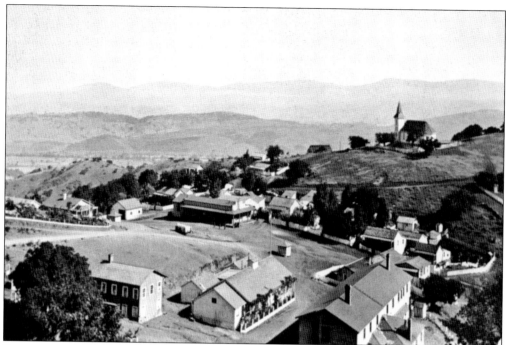

ENGLISHTOWN, C. 1900. The center of activity for Cornish miners was Englishtown, where all family needs were met. The Methodist-Episcopal Church had a commanding view of the valley. Pictured, from lower left to right, are the Boomerang Club, the Helping Hand Club, and Mrs. Faull's boardinghouse. In the center of the square is the general store and to the left, outside the photograph, is the elementary school.

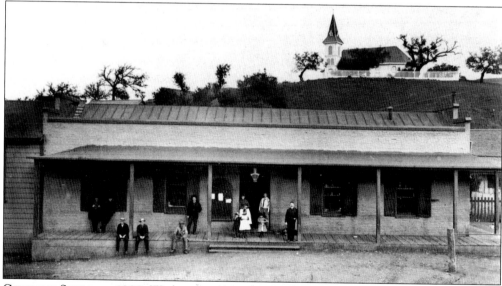

COMPANY STORE, C. 1880. Workers posed on the porch of the general merchandise store with the Methodist-Episcopal Church in the background. In 1864, Samuel Butterworth built the store as the supply center in Englishtown's plaza. He leased the store to Charles Brenham, who paid $10,000 a year in gold to Butterworth. Brenham offered a wide range of merchandise in food, clothing, and utensils. Thomas Derby became the owner in 1875.

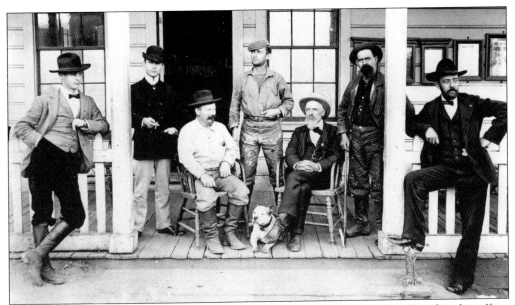

OFFICE AT MINE HILL, C. 1893. Mine, shaft, and tunnel maps were stored and used in this office. Company officials gathered at the Mine Hill office in Englishtown for a photograph. Pictured, from left to right, are Ellard Carson, surveyor; Edward W. Parker; Tom Wasley, shift boss; Charles C Derby, superintendent; Charles O'Brion, surface foreman; Richard E. Harry, mine captain; and Dr. Frank Lowell, M.D., the company doctor. (Photograph by Robert Bulmore.)

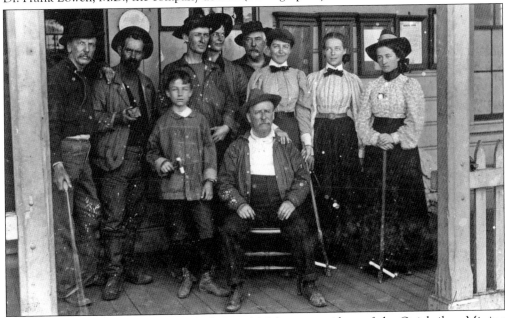

PRESIDENT MAHANY'S VISIT. Seated, David Mahany, president of the Quicksilver Mining Company, visited the mine office on Mine Hill. Standing, from left to right, are Robert Bulmore, Richard Harry, David Mahany Jr., Charles Derby, Ellard Carson, and Thomas Derby. Dressed in Gibson girl outfits are Helen Mahany, Hattie Carson, and Mrs. Charles Derby. Robert Bulmore, who held a remote cord to operate his camera, took this photograph in 1897. (Courtesy Bulmore family.)

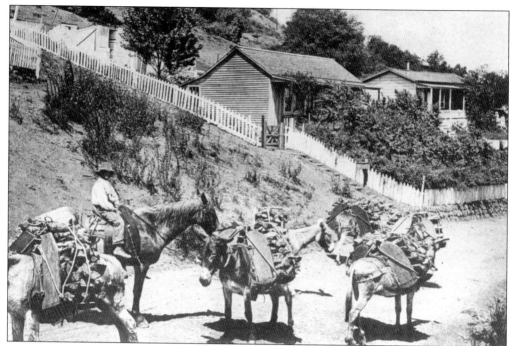

BURROS CARRYING WOOD, 1886. A wood packer, Manuel Angula led several burros loaded with wood for delivery to Englishtown residents. The house, upper center behind the fence, was the residence of Capt. James Harry, who died 1895. When Harry became the mine manager in 1892, John Drew (1869–1963), a timberman, his wife, Sarah Jane Bishop (1870–1963), and their family moved into the home. (*Views of New Almaden*.)

JOHN DREW. The son of William Thomas Drew, John was born in Grass Valley on August 17, 1869. In 1891, he married Sarah Jane Bishop on New Year's Eve. They had four children, all born at Englishtown. Following the purchase of the mines by George Sexton, John became the mine superintendent at the Senador Mine. In 1917, John Drew's payroll check was $118.75. (Photograph by J. Edward Bacon; courtesy John Drew.)

WILLIAM THOMAS DREW, C. 1865. Born in Helston, Cornwall, England, in 1839, Drew worked briefly in the mines there. In 1856, he and his wife, Mary Ann Urn, immigrated and settled in Grass Valley. Captain Harry persuaded Drew to come to New Almaden in 1884, when his son John was 14. Mary Ann Urn's father worked at New Almaden as a hoist man. After he lost the election for congress in 1886, Frank Sullivan, a democrat, contested the election. He attempted to prove that the mine management coerced the mineworkers to vote for his opponent. William Drew testified during this trial that there was no coercion. Three generations of the Drew family have worked at the New Almaden mines. (Courtesy John R. Drew.)

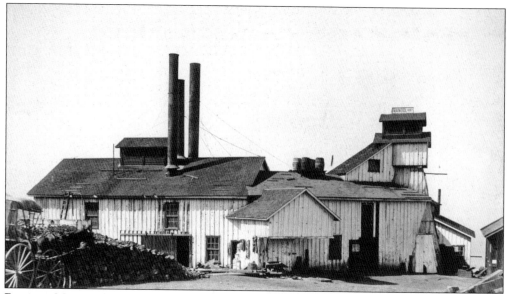

RANDOL MINE BUILDINGS, 1883. Upon becoming the new manager in 1870, James B. Randol realized that the fortunes of the company were dependent on new exploration. He ordered a new shaft to be sunk into Mine Hill, named the Randol Shaft, which became the major producer of cinnabar for the next 20 years. Mineworkers removed 300 tons of ore per day throughout this period. (Photograph by Milton Loryea and John Macaulay.)

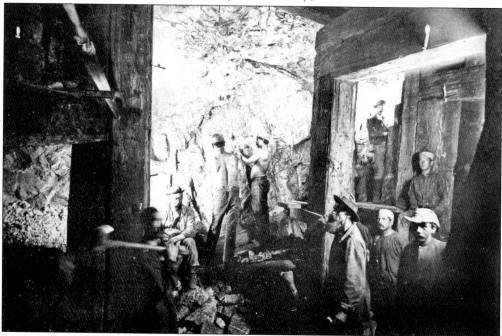

RANDOL SHAFT LABORE, 1886. This labore, the most famous underground excavation resulting from removal of ore, was at the 1,500-foot level. One-foot square redwood beams supported the tunnel. Workers at the rear drilled holes to pack with black powder in a process called double jacking. One worker held and turned the drill while the other struck it. Mine captain James Harry is in front, third from right. (*Views of New Almaden*.)

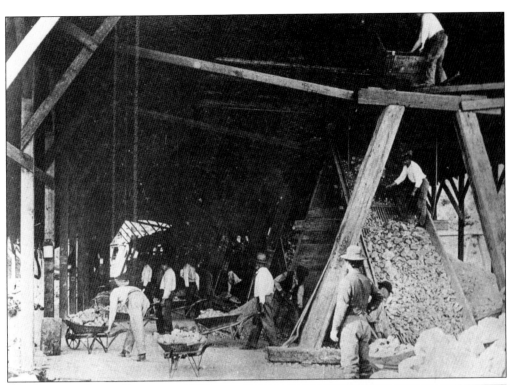

THE RANDOL SHAFT PLANILLA, 1886.
The *planilla* was a sorting shed near the Randol tunnel. At the upper right, a *limpiador* (ore cleaner) dropped ore onto a *grizzly* (a metal grate), right, to sort small *tierra* from the larger ore pieces. Ore was hand sorted into *granza* and *gruesso* and transported to the Hacienda Mine Works. Larger pieces were broken into the sizes best suited for roasting. (*Views of New Almaden.*)

CHINESE MINER, C. 1880. The Chinese first worked at the quicksilver mine in 1870. Hennen Jennings reported that about 40 to 50 Chinese worked here, mostly living near China Dump at the head of Deep Gulch Trail. They also did laundry and were cooks. According to Alex Innes, Sing Lee, laundryman and poker shark, danced and chatted in admirable Spanish with the señoritas. Most of the Chinese workers were gone by 1885.

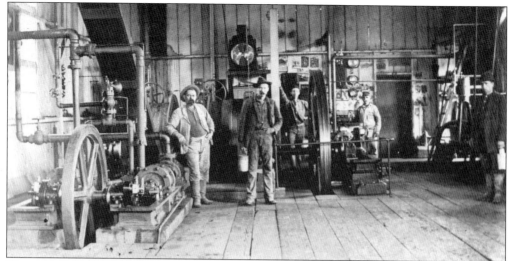

HOIST MACHINERY, 1898. There were three compartments in the Harry Shaft. Two compartments held hoists, which allowed workers and ore to rise and descend independently. A Cornish pump used the third compartment to pump water from the lower levels. Pictured, from left to right, are Richard Harry, Billy Mitchell, Ed Hopkins, John Bishop, and John Releigh. Ed Hopkins is the son of Dr. Frederick V. Hopkins and brother of the schoolteacher, Leoline Hopkins.

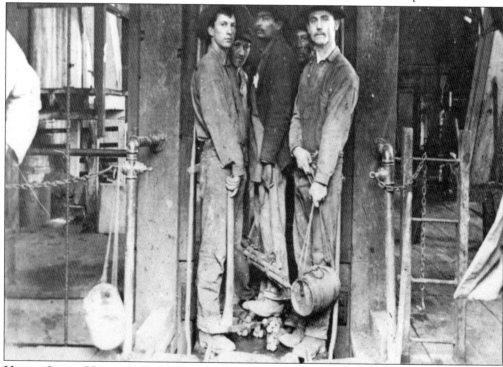

HARRY SHAFT HOIST, 1897. Miners began sinking the Harry Shaft in 1889. Shortly after mine captain James Harry became the mine manager in 1892, it was completed. Miners carried drills, picks, and a water barrel down to the working levels. Pictured, from left to right, are (first row) Fred Andrew, born in 1878, Julio Torres, and James Kessell, born in 1883; (second row) John Bennetts and unidentified. (Courtesy Bulmore family.)

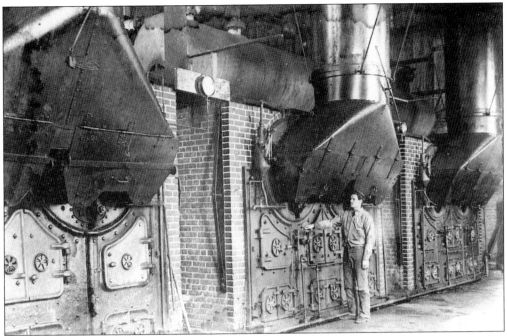

STEAM BOILERS AT BUENA VISTA SHAFT, 1886. The Buena Vista Shaft was sunk in order to pump water, up to 1,200 feet, out of the other tunnels and shafts. The huge Cornish pump removed 350 gallons per minute and worked for about eight years during the 1880s without failing. These boilers provided the steam power to drive the pumps and the hoist. (Photograph by Robert Bulmore in *Views of New Almaden*.)

VICTORIA POWDER HOUSE, C. 1989. The Victoria Powder House, built around 1865, stored black powder and dynamite. The roof was less sturdy than the walls so that an explosion would blow upward, not outward. The double walls held insulation (actually horse manure) to maintain even temperatures for the dynamite. Destroyed in the 1989 earthquake, the Santa Clara County Parks Department rebuilt it for $18,000 and dedicated it in 1994. (Photograph by Friedolin Kessler.)

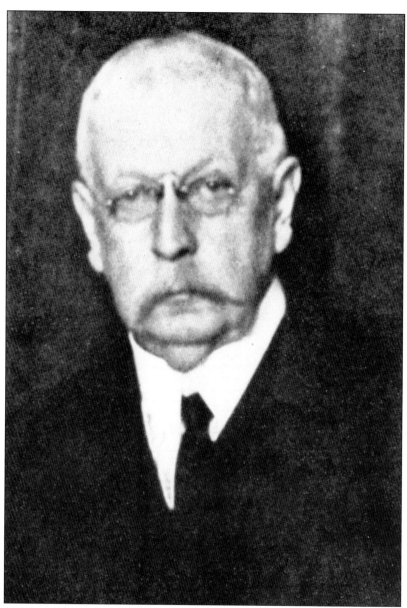

ARTHUR DEWINT FOOTE, C. 1900. Arthur Foote was a surveyor and mining engineer at the New Almaden Mine in the mid-1870s. He married Mary Hallock in New York on February 9, 1876. They chose a home on Mine Hill, with a spectacular view of the valley, rather than live at the Hacienda. On April 29, 1877, a 10-pound baby boy named Arthur Burling Foote was born in the cabin. After three years of working the mine, Arthur Foote resigned under pressure from James Randol. Mary was known nationally, having written several articles for *Scribner's Monthly*, a New York publication. She wrote "A California Mining Camp," describing in exquisite detail the life of miners in Spanishtown. She included several illustrations, including "A Girl of the Mexican Camp," "Water Carrier of the Mexican Camp," and "Cornishman 'Tramming' at the Bush Tunnel." She also wrote *A Victorian Gentlewoman in the Far West*, which describes her experiences in mining towns as she followed her husband's career. They finally settled at the Empire Mine in Grass Valley.

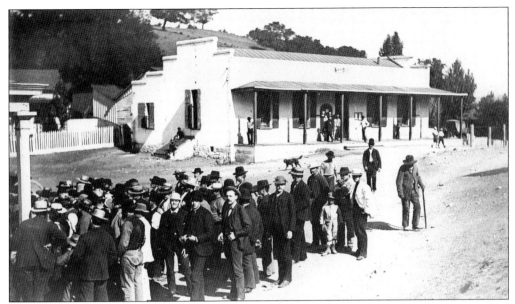

PAYDAY. Because the mine management believed the workers would not return to work if paid during the workweek, Sunday was payday and the men lined up for it. In 1864, ore cleaners were paid $2; carpenters, wagon loaders, and engine drivers were paid $3; and foremen were paid $4 per day. Other workers were paid by the ton of ore or by the foot of tunnel. (Courtesy Pfeiffer collection.)

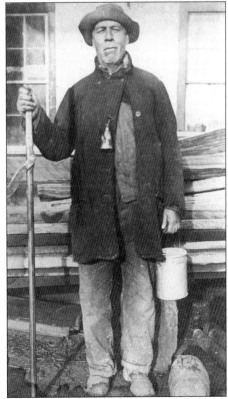

HISPANIC MINER, 1890. Patricio Avila shows off his tools. A miner's lamp fed with whale oil, also called a teapot lamp, hung on his coat. He was ready to descend into the mine, carrying a drill, his lunch bucket, and his water bucket. He dressed in layers, effectively carrying his clothing to accommodate changes in temperature between the surface and the mine. (Photograph by Robert Bulmore.)

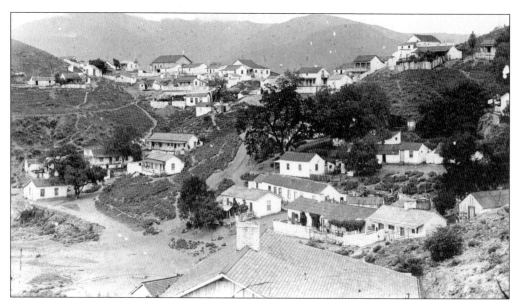

SPANISHTOWN, C. 1890. The original settlement at Spanishtown was first occupied when Andrés Castillero began mining operations in November 1845. Most of the miners were from Mexico and Chile, where mercury mining was already practiced. St. Anthony's Catholic Church and school are on the crest of the hill at the upper left. (Courtesy Pfeiffer collection.)

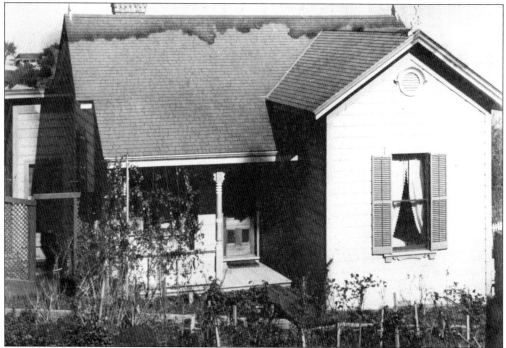

COTTAGE ON THE HILL. The Quicksilver Mining Company owned most of the homes on Mine Hill. Miners typically rented the homes for $5 per month. Those miners who owned their own homes, rented the land from the company. The gardeners at the Casa Grande kept a fully stocked nursery so that the miners could landscape their homes with shrubs, vines, roses, and flowers. (Courtesy Schneider collection.)

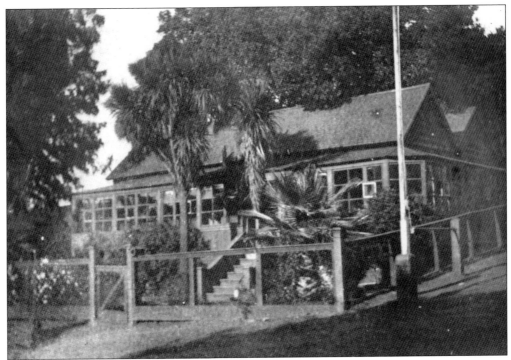

PEARCE HOME. Several members of the Pearce family worked in the mines and lived on Mine Hill. In 1865, C. E. Hawley wrote of James Pearce, "I discharged Mr. Pearce today." Hawley hired Amado Peña as a mining foreman for $4 per day, one dollar less than Pearce was paid. A few months later, Pearce was rehired and worked here for several years. (Courtesy Schneider collection.)

RICHARD PEARCE JR. One of many Pearce family members who worked at the mines, Richard Pearce operated a boardinghouse on Mine Hill. In 1880, 24 boarders were from England, one from Norway, three from Russia, and one was a native-born American. Richard Jr. worked alongside his father, Richard Sr. (1830–1913), who worked at the Buena Vista Shaft. (Courtesy Pearce collection.)

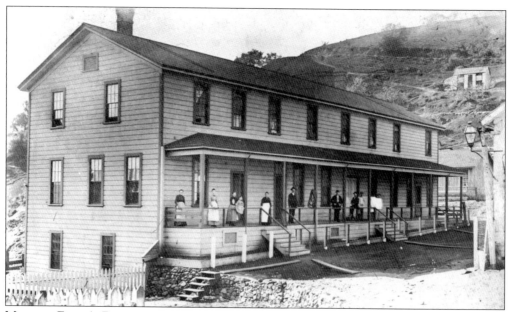

MOTHER FAULL'S BOARDINGHOUSE, C. 1880. The boardinghouse on the hill in Englishtown was established in 1865. N. D. Arnot, the mine superintendent, reported, "With houses kept by those whose interest would be identified with the company's in some small way, we would get a more perfect control of the men." Arthur DeWint Foote, a mining engineer, lived at Mother Faull's boardinghouse until he married Mary Hallock. (Courtesy Pfeiffer collection.)

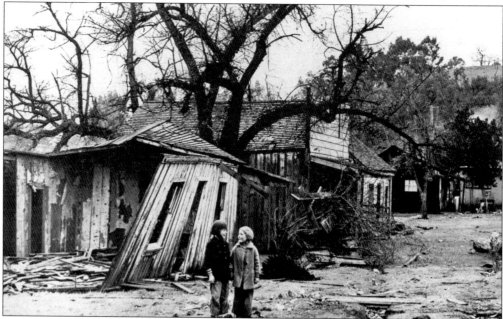

ENGLISHTOWN IN DECAY, 1937. Englishtown residents abandoned their homes and businesses after the bankruptcy of the New Almaden Quicksilver Mining Company in 1912. During the 1930s, the Civilian Conservation Corps was brought to Englishtown to remove many of the structures. Jo and Jane Schneider posed for their father, Jimmie Schneider, in this photograph. (Photograph by Jimmie Schneider.)

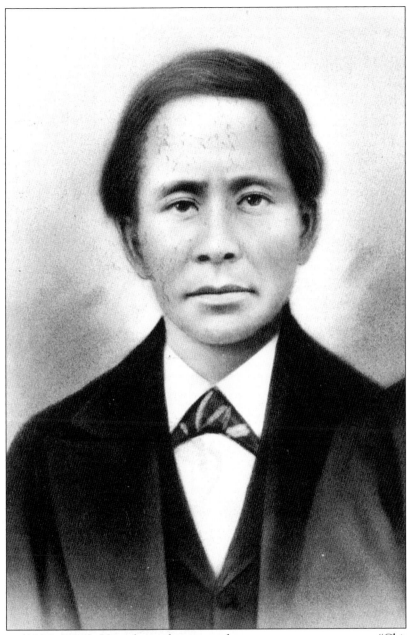

LUM HING (1830–1889). Hing, better known to the company management as "Chinese Sam" and to the miners as "Sam the Boss," began his career as a cook at the Hacienda. From 1878 to 1881, Lum Hing lived on Bertram Road in house No. 40, next to the Hacienda Cemetery, and house No. 47, next to the Hacienda Hotel. Chinese Sam was the most famous of the Chinese at New Almaden. When he became a shift boss in one of the mines, he lived at the Chinese camp near Englishtown. He abandoned the Chinese tradition of hair in a *queue* and adopted western dress. He could speak Spanish and English, as well as his native Chinese. When Sam died in February 1889, a subscription was taken by the miners and the Quicksilver Mining Company to transport Sam's family and his remains back to China to rest in peace in his native land. Hing is pictured here in 1880. (Courtesy of his great-grandson Dr. Ronald Wong, D.D.S.)

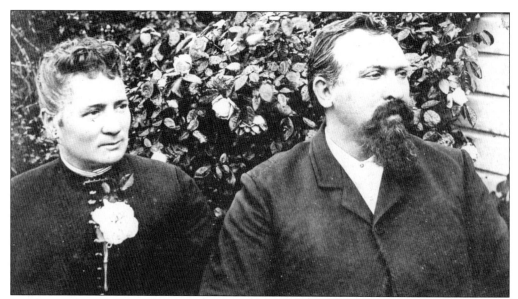

JAMES AND LOUISA ROWE VARCOE, C. 1890. In 1867, James Varcoe was a mine captain, trustee of the Benevolent Society of New Almaden, and second in command to James Harry. In 1885, he was paid $140 per month as a shaft man. Judge Innes described Louisa Varcoe as a "messenger of mercy . . . to comfort the afflicted, console the afflicted and ease the heart-sobs of fatherless children." (Courtesy Jimmie Schneider collection.)

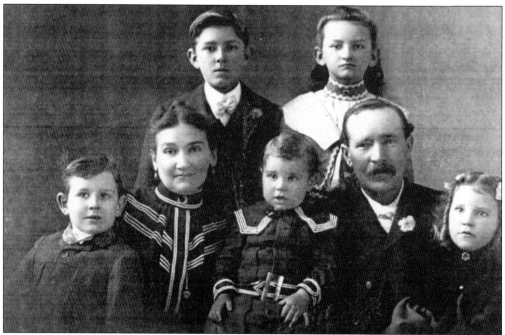

JUDGE ALEX INNES'S FAMILY, 1892. Judge Alex Innes (1848–1931) lived in New Almaden for over 50 years, served as justice of the peace for 25 years, and wrote the book the *Innes-Almaden Papers*. He was the chief engineer at the Senador Mine. Two children from his wife's first marriage and their three children, from left to right, are Cecil Innes, Mrs. Danielson-Innes, Emil Danielson, Stanley Innes, Josephine Danielson, Alex Innes, and Lydia Innes.

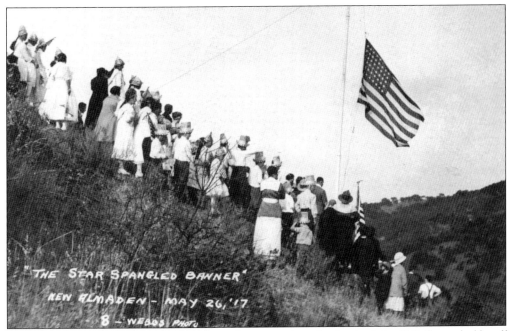

MEMORIAL DAY, MAY 26, 1917. Residents, honoring their dead, raised the U.S. flag to half-staff on Mine Hill during the war to end all wars. Fred Hauck, the mine company accountant, was in the band playing "The Star Spangled Banner." As part of the ceremony, the New Almaden Mining Company president George Sexton spoke at this event. (Photograph by Webb.)

USING A RETORT, 1939. Retorts were efficient for small batches of ore. Ore was placed into tubes from above and the upper end sealed. A fire beneath heated the cinnabar. Mercury vapor then cooled and fell into a bucket. Frank B. Pfeiffer, one of the many miners who leased parts of the New Almaden Company property in the 1930s and beyond, collected mercury from the retort. (Photograph by Ed Crowley.)

CIVILIAN CONSERVATION CORPS MONUMENT, 1992. The flagpole is the only remnant of the Civilian Conservation Corps camp in the mining area. Friedolin Kessler, a Civilian Conservation Corps corpsman, designed and built this monument in 1992 to honor the hundreds of men who lived and worked here in the 1930s. (Photograph by Friedolin Kessler.)

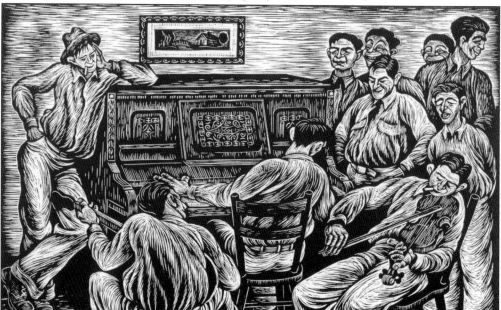

LINOLEUM CUT BY FRIEDOLIN KESSLER. While working at the Civilian Conservation Corps camp in New Almaden, Kessler cut linoleum into artistic drawings and printed these negative prints. His many prints documented the life of the corps workers from 1936 to 1938. Pres. Franklin Roosevelt received early original prints. This and other cuts are displayed and available for sale at the New Almaden Quicksilver County Mining Museum.

FREIDOLIN KESSLER (1913–1995). Kessler, pictured here in 1993, was born to a German father and a Czech mother on July 12, 1913, in St. Louis, Missouri. When his parents worked for the Busch family (of Anheuser-Busch fame) in St. Louis, the affluent Mr. Busch drove young Friedolin to school. Upon graduating from Washington University in St. Louis, Kessler joined the Civilian Conservation Corps at New Almaden as an artist. He began painting camp life in the rolling mountains but decided to make linoleum cuts of the scenes so he wouldn't have to part with the California he was recording. He continued to be involved in preserving the history of New Almaden and was a longtime member of the New Almaden Quicksilver County Park Association.

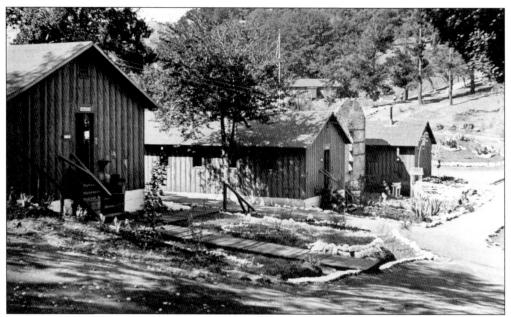

CIVILIAN CONSERVATION CORPS BUILDINGS, 1938. Pres. Franklin D. Roosevelt established the corps during the Great Depression in order to provide jobs for unemployed men. The Mount Madonna Camp No. 736, based in Englishtown, had up to 100 men working to remove abandoned buildings on the hill. When necessary, they were also diverted to controlling fires in the hills surrounding Santa Clara Valley. (Photograph by Friedolin Kessler.)

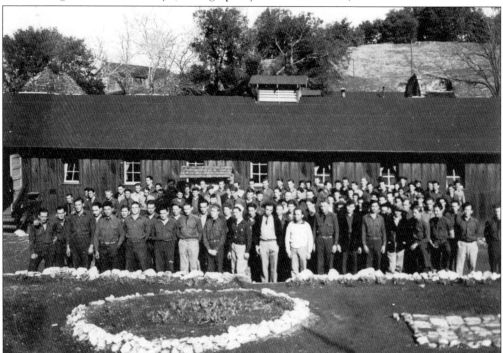

CIVILIAN CONSERVATION CORPS WORKERS, 1936. About 91 workers posed in front of the barracks at Englishtown, all part of the Civilian Conservation Corps. (Photograph by Friedolin Kessler.)

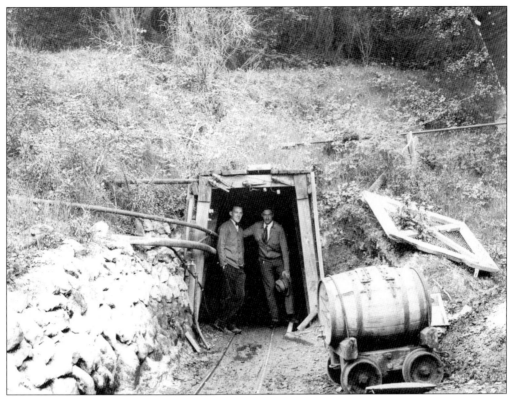

SENADOR MINE ENTRANCE, C. 1925. The Senador Mine, at the north end of the New Almaden Mine property, was developed from 1915 to 1926, though people had known about it since the 1860s. The entrance was eight feet tall and wide enough for a narrow-gauge railcar. A barrel was used to bring water into the mine. The mine entrance was in the hillside to the left of and above the current Senador Mine trail.

SAN MATEO MINE, 1939. The San Mateo was one of the many mines listed at Mine Hill. Pictured, from left to right, are Steve Marrajo, Louis Rossi, Bob Dennis, and Elmer Rossi. Louis Rossi invented the "Rossi Retort" in the early 1930s, which allowed small batches of ore to enter from above, roast, and then be removed below. In a retort, ore is heated indirectly so that fumes from the source of heat do not contaminate the quicksilver.

JIMMIE SCHNEIDER, C. 1960. A group of local residents—Hans Buck, John A. Cussen Jr., Paul A. Mariani Jr., W. Matthew Looney, Leonard Rubino, Sam R. Abinante, and Phillips S. "Jimmie" Schneider—purchased the Almaden Mine Company from the Sexton estate in 1960 for production and possibly for real estate development. Jimmie Schneider, left, is holding a carbide lamp in his hand. (Courtesy Schneider collection.)

MINE HILL FIRE, SEPTEMBER 1968. The county fire department deliberately set fire to the old Civilian Conservation Corps barracks at Englishtown for fire training for their recruits. Setting this fire reduced the danger from vandals or other fires that could destroy the extremely dry wooded areas around Englishtown.

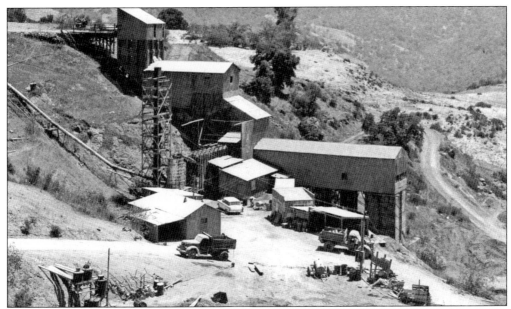

35-TON ROTARY FURNACE, C. 1962. As World War II loomed in 1939, the New Almaden Mining Company purchased and installed a new rotary furnace in Spanishtown. Invented by Henry W. Gould, this furnace allowed ore to be entered at the top. Ore was then rotated in a huge pipe while heated and the remains discharged at the right into waiting trucks. Mine Hill was strip-mined and ore brought here by the truckload.

NEW IDRIA MINING COMPANY STAFF, 1969. In 1968, the New Idria Mining and Chemical Company of Fresno purchased the New Almaden Mines from the Cordero Mining Company and added a new 100-ton rotary furnace next to the existing 35-ton furnace at Spanishtown. Pictured, from to left to right, John Atwood and Owen Challender surveyed the tunnels, Robert Linn was the mine manager, and Victor Botts was a geologist. (Courtesy John Atwood.)

BIBLIOGRAPHY

Books and publications listed here were valuable for our research and study. Since this book about New Almaden is just a snapshot of its history, readers may find the books listed below as valuable companions. Some are available for sale at the New Almaden Quicksilver Mining Museum.

Allen, Rebecca and Mark Hylkema. *Life Along the Guadalupe River.* San Jose, CA: The Press, 2002.

Bailey, Edgar H. and Donald L. Everhart. *Geology and Quicksilver Deposits of the New Almaden District Santa Clara County California.* U.S. Government Printing Office, 1964.

Bradley, Walter W. *Quicksilver Resources of California.* California State Printing Office, 1918.

Browne, J. Ross. "Down in the Cinnabar Mines." *Harper's New Monthly Magazine,* Volume XXXV, 1865.

Christy, Samuel B. *Quicksilver Condensation at New Almaden, California.* Sherman and Company, Printers, 1885.

Demers, Donald O., ed. *Life in the Mines of New Almaden.* San Jose, CA: San Jose Historical Museum Association, 1978.

Foote, Mary Hallock. "A California Mining Camp." *Scribner's Monthly* magazine, February 1878.

Johnson, Kenneth M. *The New Almaden Quicksilver Mine.* Georgetown, CA: The Talisman Press, 1963.

Lanyon, Milton and Laurence Bulmore. *Cinnabar Hills.* Los Gatos, CA: Village Printers, 1967.

McKinney, Gage. *A High and Holy Place.* Sunnyvale, CA: Pine Press, 1997.

Neilson, Rich. *The History of the Chinese at the New Almaden Quicksilver Mine: 1850 –1900.* Unpublished.

Peterson, Douglas and Linda Yamane. *The Ohlone People of Central California.* Santa Clara County Parks and Recreation Department.

Schneider, Jimmie. *Quicksilver.* San Jose, CA: Zella Schneider, 1992.

Vallejo, Mariano Guadalupe and Padre Francisco Palou. *Great Indians of California,* Santa Barbara, CA: Bellerophon Books, 1999.

Winn, S. E. and Robert Bulmore. *Views of New Almaden.* San Jose, CA: 1878.

INDEX

Across America, People are Discovering Something Wonderful. Their Heritage.

Arcadia Publishing is the leading local history publisher in the United States. With more than 3,000 titles in print and hundreds of new titles released every year, Arcadia has extensive specialized experience chronicling the history of communities and celebrating America's hidden stories, bringing to life the people, places, and events from the past. To discover the history of other communities across the nation, please visit:

www.arcadiapublishing.com

Customized search tools allow you to find regional history books about the town where you grew up, the cities where your friends and family live, the town where your parents met, or even that retirement spot you've been dreaming about.